The Beginner's Guide to
CHINESE PAPER CUTTING

By Zhao Ziping

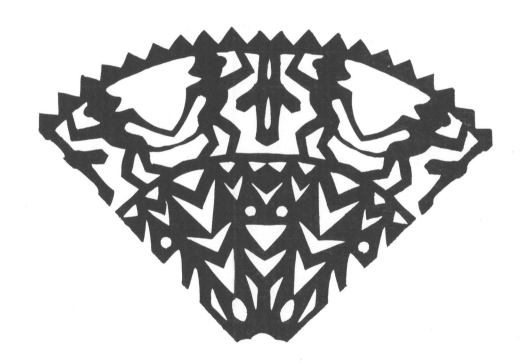

Copyright © 2013 Shanghai Press and Publishing Development Company

This book is edited and designed by the Editorial Committee of *Cultural China* series

Managing Directors: Wang Youbu, Xu Naiqing
Editorial Director: Wu Ying
Editors: Yang Xiaohe, Kirstin Mattson
Editing Assistant: Wu Yuezhou

Text and Works by Zhao Ziping
Translation by Cao Jianxin
Photographs by Ding Guoxing, Quanjing

Cover Designer: Wang Wei
Interior Designers: Li Jing, Hu Bin (Yuan Yinchang Design Studio)

ISBN: 978-1-60220-136-1

Address any comments about *The Beginner's Guide to Chinese Paper Cutting* to:

Better Link Press
99 Park Ave
New York, NY 10016
USA

or

Shanghai Press and Publishing Development Company
F 7 Donghu Road, Shanghai, China (200031)
Email: comments_betterlinkpress@hotmail.com

Printed in China by Shanghai Donnelley Printing Co., Ltd.

1 3 5 7 9 10 8 6 4 2

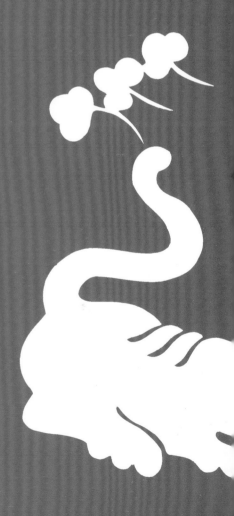

On page 1
"Symmetrical Monkeys" based on the paper-cuts unearthed from the ancient tombs at Astana, Turpan, Xinjiang

Right
Tiger & Dragon

Contents

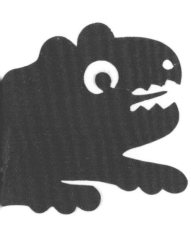

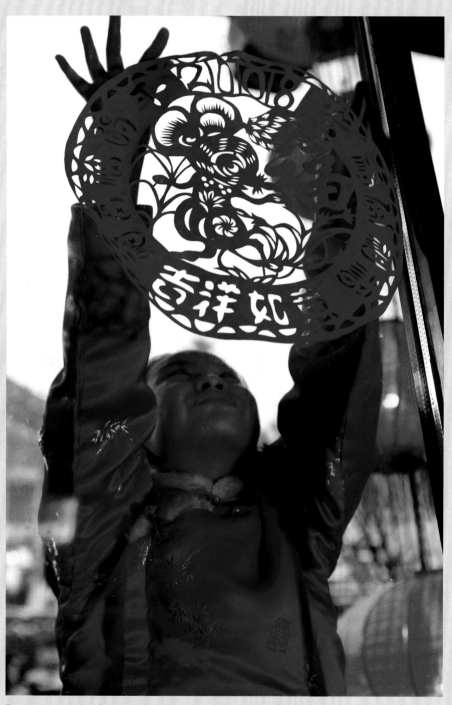

Paper-cuts create a festive atmosphere during China's Spring Festival.

Introduction

Paper cutting is one of the most popular of China's traditional decorative arts and crafts. With a long history, the art of paper cutting remains a vital part of people's lives thanks to its vividness and loveliness as well as its practicality, using materials that are inexpensive and readily available.

Paper cutting varies throughout China as different areas have developed their own local styles. However, they all serve as expressions of beauty and wishes for good luck, and the art of paper cutting, with its distinctive language of artistic expression, is a true example of traditional culture. This fact was formally recognized in 2009, when Chinese paper cutting was listed by the United Nations Educational, Scientific and Cultural Organization (UNESCO) in its Intangible Heritage Lists.

Origin and Development

Paper cutting's history can be traced back nearly 2000 years. Even before the invention of paper, cutting and engraving on thin materials already existed. However, paper cutting in its true sense appeared in 105 when Cai Lun of the Han Dynasty invented paper. The introduction of paper cutting followed soon after and had already become popular in the Tang Dynasty (618 – 907). People also used thick paper to engrave flower stencils, which were used to dye cloth with beautiful patterns.

As the paper-making industry became more mature, paper cutting became even more popular. In the Song Dynasty (960 – 1279) for example, it was used for window

and door decorations called *chuang hua*, meaning "window flower," or to decorate tea cups and other everyday objects. Paper cutting techniques were also used in other industries. For example, Jizhou kilns in Jiangxi Province used paper-cuts as patterns for ceramics; paper cutting techniques were used to carve animal hides into shadow puppet figures, and so on.

In the Ming Dynasty (1368 – 1644) and Qing Dynasty (1644 – 1911), the art of paper cutting reached its peak, and was applied even more extensively, including on lanterns,

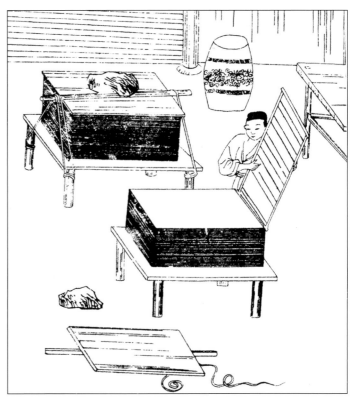

Paper-making procedures in *Tian Gong Kai Wu* or *The Exploitation of the Works of Nature* by Song Yingxing, published in May 1637.

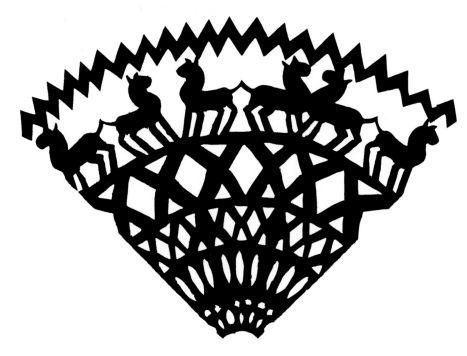

"Symmetrical Deer" based on the paper-cuts unearthed from the ancient tombs at Astana, Turpan, Xinjiang

fans and embroideries. The most common use of paper-cuts was to decorate houses including the doors, windows and cabinets.

The earliest paper-cuts in existence are two pieces of cluster flower paper-cuts discovered by Chinese archaeologists in the 1960s in tombs of the Northern Dynasty (386 – 581) in the Astana complex located in the Turpan Basin in China's far west. Using jute paper, they were symmetrical paper-cuts used for rituals, and now are preserved in the Museum of the Xinjiang Uygur Autonomous Region.

Significance of Paper-Cuts

Paper cutting uses images from real life but with exaggerated forms. It attempts to capture the spirit of figures, creatures and symbols that have profound cultural significance, especially those traditionally used to express hopes for a bright future. Paper-cuts are crucial to many traditional and folk rituals, such as marking significant festivals or life events.

The four seasons and traditional celebrations are exceptionally valued in China, and paper cutting is used for decoration at these times. For example, at the Spring Festival (Chinese New Year), red paper-cuts of the Chinese character 福 (fu, meaning good fortune) bring wishes for good luck and a warm atmosphere to the celebrations. Other popular paper-cut patterns, such as flowers (plum blossom, orchid, bamboo, chrysanthemum, lotus and lotus root), golden roosters and leaping fish, express people's wishes for luck and success in the new year, as well as continual prosperity, peace and blessings.

During the Lantern Festival, celebrated on the fifteenth day of Chinese New Year, children everywhere play while carrying lanterns pasted with "lantern flowers," a special and lovely type of paper-cut. In some regions, during Qingming Festival, also called Tomb Sweeping Day, a traditional type of paper money is left at tombs in remembrance of one's ancestors. Among the decorations

is a set of colorful paper-cuts, patterned with auspicious symbols including Chinese characters and legendary immortals, which are fastened to bamboo sticks and displayed at the ancestors' tombs.

Traditionally, girls in China learn the needle arts, including embroidery, spinning, weaving and making clothes, from their mothers or aunts. Paper cutting and embroidery are inseparable sister crafts because embroidery often uses paper-cuts as patterns to create stitchery on fabrics. For example, there are three types of paper-cuts conventionally used as patterns in embroidering cloth shoe uppers.

In olden times, before arranging a marriage, a match-maker would be sure to seek an opportunity to let the bride-to-be show off her skills in paper cutting and embroidery. After the bridegroom-to-be expressed his interest, the bride-to-be would then present him with a pair of exquisitely embroidered insoles or cloth sandals as a love token. These could be decorated with any of a number of traditional patterns including a magpie with plum blossom, cowherd and weaving maid, dragon and phoenix rejoicing, mandarin ducks playing in water, the child-giving Goddess of Mercy or pomegranate trees heavily laden with fruit. These patterns might serve to wish for conjugal bliss, love for a lifetime, the early birth of a baby and being blessed with numerous sons.

In a tradition that continues to the current day, during the marriage ceremony, paper-cuts of the Chinese character pattern 囍 (喜, *xi*, means happiness. The two *xi* characters side by side signify double happiness) would be posted everywhere. This character pattern is often seen in combination with such images as magpies, plum blossoms, fish, lotuses and mandarin ducks, strengthening its symbolic significance.

Paper-cuts are often given as birthday presents representing the folk custom of

Paper-cuts are often found at wedding ceremonies in China.

respect for the elderly. On these occasions, the patterns often feature symbols traditionally associated with long life, prosperity and happiness, including the deer and crane celebrating spring, the pine-crane and the South Mountain.

In addition to their use for specific festivals or events, paper-cuts are also very suitable for everyday decoration at home. After creating an appropriate piece, one need only flatten it, mount it and place it in a frame, thus producing a unique work of art.

Paper Cutting Styles

Paper cutting is practiced throughout the world and collectively constitutes a true art treasure. Chinese paper-cuts are readily distinctive from paper-cuts of other countries in terms of their content, form and technique. Paper-cuts in Western countries mainly take human figures as their subject, with the frequent use of silhouettes, mostly in white and black. The technique they use is

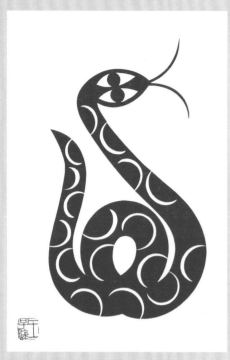

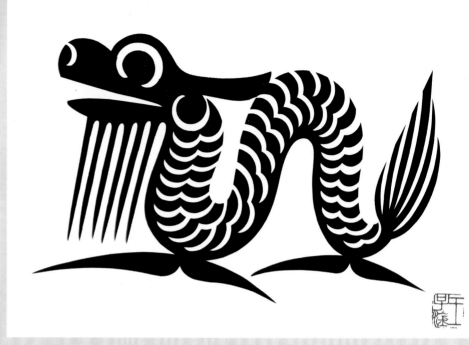

Work of Wang Zigan—Snake (1980s)

Work of Wang Zigan—Chinese Dragon (1980s)

relatively exaggerated and full of imagination although they show great variety in form reflecting local styles.

For example, in Poland, typical paper-cuts are symmetrical patterns of flowers and birds, especially symmetrical roosters. In Denmark, paper-cuts often take as their theme the famous fairy tales of Hans Christian Andersen. Traditional German paper-cuts take the form of silhouettes or cuttings describing daily life. In Japan, paper-cuts borrow from the forms and techniques of woodblock printing.

As mentioned previously, within China there is regional variety. The Shanghai style enjoys an extraordinary status and is recognized as the National Intangible Cultural Heritage of China. Wang Zigan (1920 – 2000), the founder of Shanghai-style paper cutting, was superbly skilled and specially honored as a "Wonderful Cutter." His paper-cut works epitomize the characteristics of the Shanghai style: they integrate ease, elegance, delicacy and fluidity, and use exaggerated and simple forms with rich cultural connotations.

Beginning in 1956, Wang Zigan created paper-cuts and researched the art of paper cutting at the Shanghai Arts and Crafts Institute. In 1962 at the age of nineteen, I became Wang Zigan's first apprentice.

Over the past fifty years, I have been engaged in the art and study of paper cutting, and in 2009, following in the footsteps of my mentor, I was named the "Successor of Shanghai-Style Paper Cutting Art, Intangible Cultural Heritage Project of Shanghai."

In order to respond to environmental concerns, I have further developed the style and my creative approach calls for the cutting of two works (one of yin style and another of yang style) at the same time, which is described in a later chapter. This approach, in addition to the use of recycled paper, cuts down on waste in creating magical works of art.

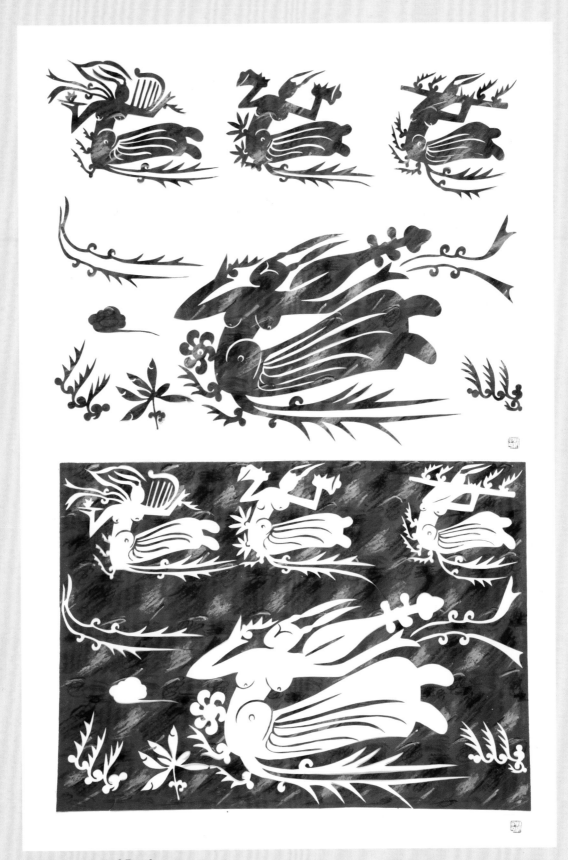

Flying *Apsaras* of Dunhuang

This paper-cut shows the flying *apsaras* (celestial maidens) of the Dunhuang Grottoes, the famous Buddhist cave art site in northwest China. In this example the author uses the yin yang method to create two complimentary works with a total of eight *asparas*. Different musical instruments rest in the *asparas*' hands, and you almost feel as if you can hear the beautiful concert from afar.

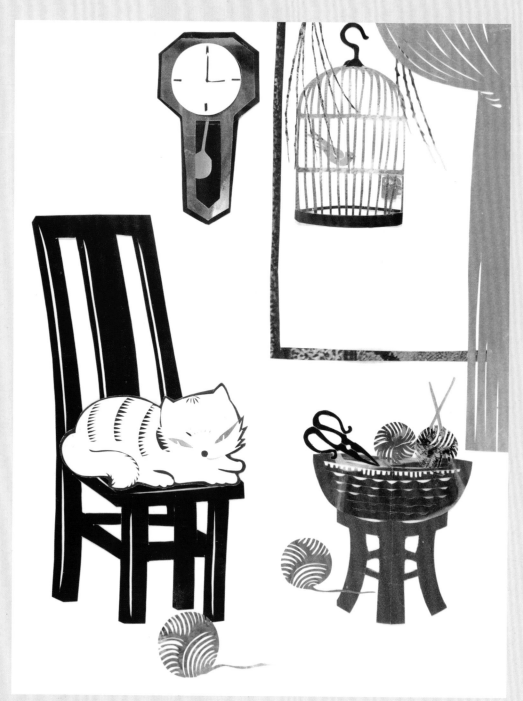

The Tranquil Home

This paper-cut shows a serene afternoon scene in the home of an average Chinese family. Paper from ordinary magazines is used to make the bird cage, woven basket, wall clock, window frames and balls of wool, although not the chairs. You should choose pages whose colors and patterns are similar to those of the objects.

 The approach to the cat is a bit different. First, the cat is cut out of white paper. Then the white cat is put onto a colorful page from a magazine, and the shape is cut out of this paper, but only slightly larger. When the white cat is pasted on top of this shape, there will be a colorful outline around the cat, providing a lively, three-dimensional effect.

Chapter One Preparation

Paper cutting can cultivate a person's imagination and aesthetic sense. It also has other benefits: increasing discipline and confidence and instilling a sense of accomplishment. The practice of paper cutting strengthens coordination and dexterity of the hands and brain, heightens spatial awareness, and promotes the physical and mental health of the cutter.

Having the correct materials and tools forms the basis of good paper cutting, while learning the right techniques and dedicated training will bring the highest level of quality and artistic value to paper-cut works.

Only scissors are used in the art of paper cutting in the true sense. This is different from paper engraving or stenciling, in which the designs are first drawn on paper and then cut with a knife. Drawing is not used in paper cutting; one uses scissors instead of a pen to create designs.

To create a successful work, the hands and brain must cooperate harmoniously, combining dexterity with the rich imagination of the cutter. Practicing basic techniques is vital. Creating excellent paper-cuts can only be completed after hard work and practice of many years based on solid basic skills and mastery of techniques.

At the same time, paper cutting requires only simple materials and can bring enjoyment and other benefits from the very beginning of one's practice. Starting with only a pair of scissors and a piece of paper, you can bring your imagination and potential into play and find fun in paper cutting!

Principles and Method

Every art form varies in tools, materials and forms of expression. A good paper-cut is marked by its simple composition, its ease of form, the neat arrangement of its lines and the beauty of its image.

When creating a piece of work, it must first be thoroughly thought through, with the theme selected before beginning composition. The composition must be simple and smoothly executed. Chinese paper cutting mainly uses what is known as the "cavalier perspective method," i.e. the pictures should be flat, avoiding both complicated perspective and attempts at sculptural modeling. This simplicity does not weaken the impact but rather makes the paper-cuts more striking.

Chinese paper cutting is characterized by exaggeration and manipulation of forms, interpreting and magnifying the most characteristic parts of the subject whether human, plant, animal or symbol. Plain and elegant, paper-cuts do not rely on rich color changes or transitions from light to dark. A good paper-cut work requires consideration and deliberation.

This book introduces two main paper cutting methods: symmetrical cutting of a folded piece of paper and freeform cutting without paper folding.

Symmetrical paper cutting is also called folded paper cutting because the technique involves folding a piece of paper in the middle before cutting, with the complete work being unveiled after unfolding. Symmetrical paper cutting is the most common form of Chinese paper cutting. It is used for the popular theme of "double happiness" using the Chinese

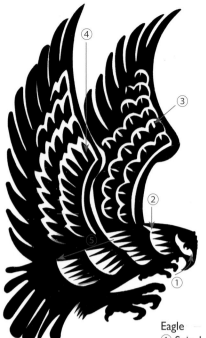

Eagle
① Snip 1 ② Snip 2 ③ Snip 3
④ Snip 4 ⑤ Snip 5

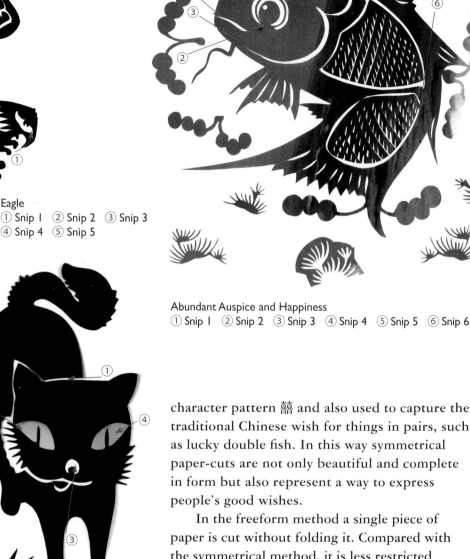

Abundant Auspice and Happiness
① Snip 1 ② Snip 2 ③ Snip 3 ④ Snip 4 ⑤ Snip 5 ⑥ Snip 6

Black Cat
① Snip 1 ② Snip 2
③ Snip 3 ④ Snip 4

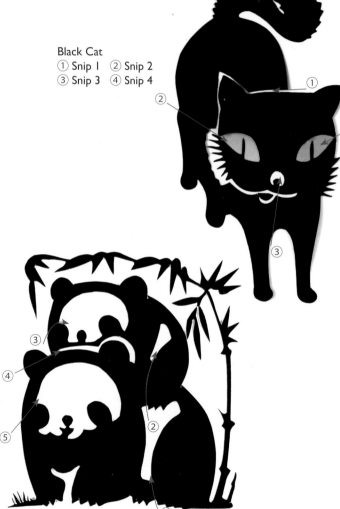

Mother Panda and Her Baby
① Snip 1 ② Snip 2 ③ Snip 3 ④ Snip 4 ⑤ Snip 5

character pattern 囍 and also used to capture the traditional Chinese wish for things in pairs, such as lucky double fish. In this way symmetrical paper-cuts are not only beautiful and complete in form but also represent a way to express people's good wishes.

In the freeform method a single piece of paper is cut without folding it. Compared with the symmetrical method, it is less restricted and requires a higher skill level. There is no preliminary drawing on the paper, and so the work must be fully conceived in the mind before the first cut is made.

The common practice is to first cut the external outline of the works and then the patterns in the middle. When working on the patterns in the middle, you will first need to make a preliminary "snip" to start the opening where the pattern is. No traces of these "snips" should be found on the completed works; they should be fully integrated into the patterning. If you are right-handed, you will gradually cut the patterns in detail counterclockwise from the right to the left.

Equipment and Materials

When purchasing scissors, make sure they appropriate for the size of your hands and check whether they are comfortable. You should choose light scissors with appropriate tightness, sharp blades, and pointed and even tips. If scissors become too tight when used, use a hammer to knock at the rivet in the middle lightly to loosen it slightly for freer and smoother use. Children should use safety scissors with rounded tips.

Choose scissors that fit the size of your hands.

It is also very important to take care of scissors:

- Keep your paper cutting scissors separate from other scissors. Never use them to cut other materials because it will damage blades.
- Handle scissors with care and avoid dropping. Otherwise, the tips may be damaged or the blades may loosen.
- Clean scissors after paper cutting.
- Keep scissors dry and avoid storing in a damp environment that will cause rust.

Since paper is the basic material for paper cutting, it is crucial to choose it carefully. It is best to use relatively thin, flexible and wear-resistant paper. During paper cutting, sometimes paper needs to be folded into several layers. If paper is hard and fragile, it will break, making it difficult to complete delicate works and affecting the aesthetic impact.

The color depends on the use and subject of the paper-cut. Red paper-cuts are often used in traditional festivals, while white, black and blue works have a more contemporary feeling and are popular among young people.

Chinese people like using scarlet paper, a certain type of soft paper that is dyed red only on one side; however, it is fragile and fades easily. Another commonly used paper is glazed paper that is bright, lustrous, colorful, thin and easy to fold. It is also relatively fragile and is also slippery and tends to lose shape.

Paper cutting art today often uses rice paper, which not only has a strong traditional style but is easy to cut and fold. It can also be dyed rich colors after the completion of works. Now there is also a focus on the environment, which has led to the appearance of many new environmentally-friendly materials and the use of recycled materials, for example making paper-cuts using pages from color magazines.

When beginning your practice, there is no need to buy special paper. Used newspapers and magazine pages can be used for practice. When you become more accomplished, you can incorporate different types of paper into your works to vary modes of expression.

Body Posture

As when practicing calligraphy, your posture when paper cutting is important. Traditionally it is said that a cutter must "sit like a bell." Your feet should be hip-width apart and planted on the ground. Your shoulders should be even, back straight but comfortable and chest up. Your eyes should keep focus on the materials to be cut while you breathe evenly. Maintaining this posture can make a cutter feel at ease and concentrated, thus bringing about ideal works.

After working for a long time, be sure to stretch your arms for some relaxation. When picking up the scissors again, adjust posture appropriately so that paper cutting can be practiced optimally while the cutter stays healthy.

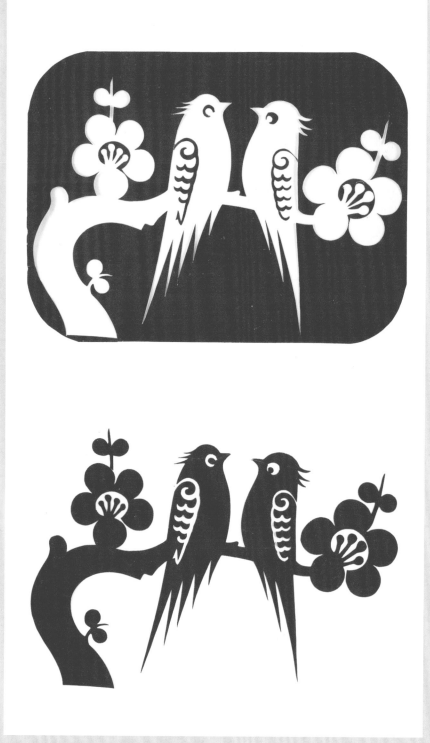

Double Birds and Plum Blossoms

This work uses the yin and yang paper cutting method to create two separate paper-cuts from one piece of paper. The yin paper-cut (above) shows the plum blossoms and birds in white (the red parts being cut off), while in the yang work (below), the plum blossoms and birds are in red.

Chapter Two **Basic Practices**

Learning Chinese characters begins with strokes; to learn paper cutting, begin with lines. Your initial skill training should extend for a considerable period of time, bringing about hand-eye coordination and confidence. Start by cutting straight lines, row lines, cross lines and loop lines, increasing your manual dexterity and feeling. First cut the lines coarsely and large, then develop fine, small cuts. Although some of them look simple, it needs repeated practice to master. Long-term training brings about increased coordination among brain, eyes, hands and scissors.

1. Straight Lines

This is the most basic practice in paper cutting, mainly training the cutter's visual ability. Straight lines should be forceful with clear intersections. When cutting a square, the four sides must be equal and intersect at right angles. During practice, each cut should be completed at one go without pause.

2. Row Lines

Practice row lines after practicing straight lines. Row lines should not only be straight but there should also be equal distance between lines. This practice tests a cutter's ability to cut straight lines as well as one's visual ability and patience.

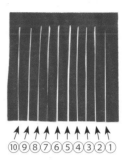

3. Cross Lines

Cut out four identical small squares from the corners of a square paper. Cutting this kind of line is another means of training the coordination and response abilities of brain, eyes and hands.

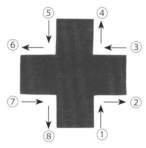

4. Loop Lines

Use the same method as that of cutting straight lines, being sure to keep the same size and length.

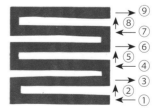

5. Circle

If you are right-handed, place the thumb and forefinger of your left hand on either side of the center of a piece of square paper. Turn

the paper clockwise with your left hand while the right hand continues cutting. Cutting and turning should be coordinated, keeping the cutting smooth and making it easier to cut a more perfectly round circle.

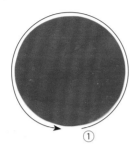

6. Spiral

First cut a circle, and then cut towards the center in a descending spiral, making the whole shape look like a spring. During cutting, pay attention to maintaining an evenly spaced and continuous spiral. The arcs should be smooth while inner and outer curvatures should be synchronized.

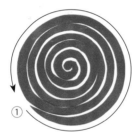

7. Parabolic Cross-Lines

This form is created by cutting four identical small arcs off the four corners of a square paper.

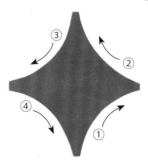

8. S-shaped Lines

It will be easier to cut an S-shaped line after you have grasped the technique of cutting a circle. The purpose of cutting S-shaped lines is

to practice the coordination between the right and left hands in order to bring about round and smooth lines.

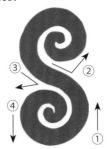

9. Heart

First cut upward and to the right from the bottom, then cut two small round semicircles. Finally cut the arc at the bottom. Lines should be round and smooth, and the heart cut out should be bilaterally symmetrical. Practice this without folding the paper to train preciseness and coordination.

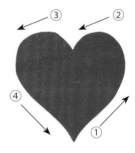

10. Gourd

Unlike the heart, this paper-cut starts at the top. After the stem, cut downward to create an arc and then a large semicircle. After cutting the round bottom, cut upwards to create a large semicircle and then another arc before finishing at the top stem. Like the heart paper-cut, the gourd should be cut round and smooth, and it should be bilaterally symmetrical.

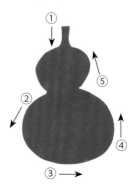

11. Combined Rotating Crescents

Cut openings of identical form and size following from ① to ②, producing a dynamic work. Make sure that lines are smooth and round with equal space between crescents and the cuts equally deep toward the center.

12. Bamboo-Leaf

First cut the exterior form and then the center veins of the bamboo leaves, which must be thin and straight.

13. Undersea Coral

Cut at one go following the order from ① to ④. The ends should be smoothly rounded, and while the shape may look clunky the lines are actually delicate.

14. Pine-Needles

Cut following the order from ① to ⑥. Before cutting, however, you must understand the overall layout, seeing it first in your mind. Then cut neatly and evenly so that pine needles are full of vitality.

15. Cloud

Cut from ① to ⑦, creating a smooth shape that conveys the soft feeling of clouds.

16. Water Streams

Work around from ① to ⑧, cutting smoothly using coordination between the right and left hands to maneuver around the shape. Keep in mind the pattern of the Chinese character 水 (*shui*, water).

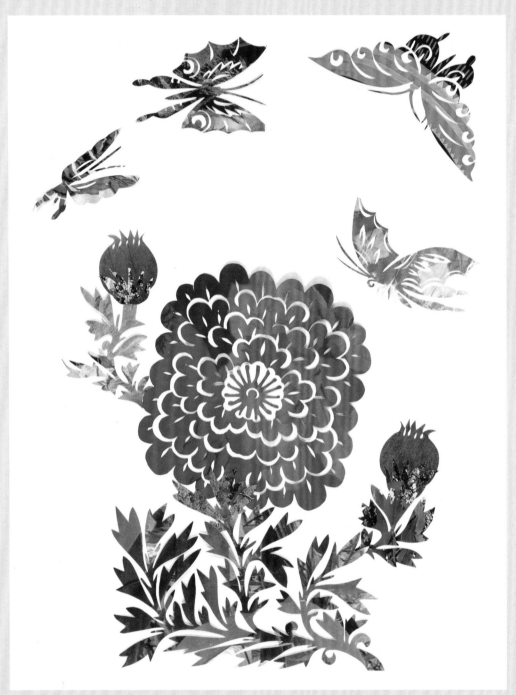

Butterflies in Love with a Flower

This paper-cut work takes as its subject peonies, symbolizing the female, and butterflies, which symbolize the male. This pattern of "butterflies in love with a flower" indicates sweet love and happy marriage, expressing the deep affection between male and female.

In this paper-cut, magazine paper is used for the peony, leaves and butterflies. First choose pages whose colors and patterns are appropriate for the subjects. Then the elements of the composition can be designed and cut.

Chapter Three Flower Paper Cutting

Flowers are the most common, and perhaps the loveliest, subject for paper cutting. The variety of nature—delicate and charming blossoms, plain and young leaves, sturdy or intertwining stems—is wonderful.

In addition to their beauty, flowers have many meanings in traditional Chinese culture. For example, graceful and gorgeous peonies are regarded as "exquisite beauties" that can symbolize prosperity, magnolias can represent purity and feminine beauty, and chrysanthemums have always been the symbol of nobility.

The following is an introduction to some of the most common and popular flower paper-cuts. The basic method is cutting from the right to the left. Careful observation of the actual flowers in nature will help you to produce more charming and attractive paper-cut works.

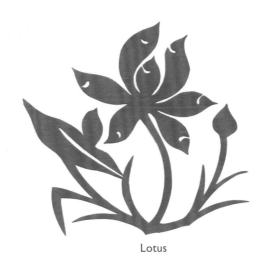

Lotus

Symmetrical Patterns

These flowers are cut using the bilateral symmetrical paper cutting method: a square piece of paper should be folded in half before cutting, and you only cut half the pattern. The designs you see below show the whole paper-cut after it has been unfolded. You can cover up the left half of these patterns in the book to guide you when cutting using this method. Flowers cut with the symmetrical method are concise and use appropriately exaggerated forms.

1. Heart-Shaped Leaf

After folding a piece of square paper in the middle, cut from the tip at the top keeping the lines even. If you are unhappy with the result, do not go back and try to fix the lines, but instead cut again from the beginning.

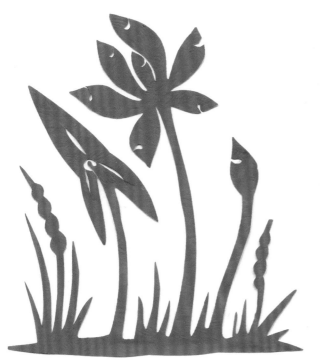

Lotus

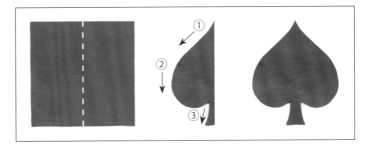

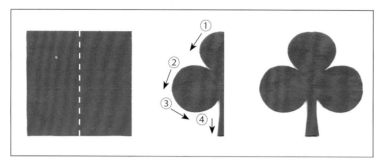

2. Clover

Fold a piece of square paper in the middle, and cut downward from the top, making a semicircle. The cut is a nearly full circle at one beat without pause. Then create the stem. If the result is undesirable, start again. After unfolding, the size of three circles should be the same.

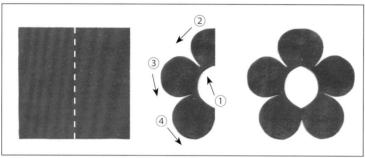

3. Plum Blossom

After folding your paper, first cut a semicircle at the center on the folded side, representing the core of plum blossom around which the petals will rotate. Then cut the petals of the plum blossom on the other side of the paper, working either from the top or from below. You must only cut two and a half petals because this will create a flower with five uniform petals after unfolding.

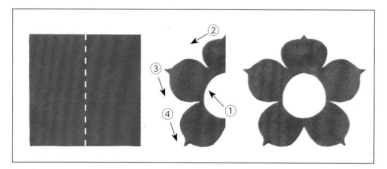

4. Peach Blossom

The peach blossom has a similar form to that of the plum blossom and the only difference is the petal shape: the top of the petal of the peach blossom is pointed rather than round. Follow the instructions above for cutting the plum blossom, taking care to add a point to the circular form of the petals.

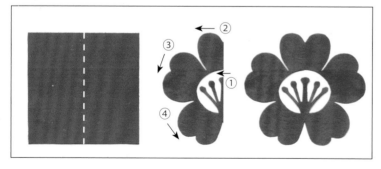

5. Cherry Blossom

The cherry blossom has a relatively complicated shape. When cutting the core, leave the fan shape of a stamen in the center of the void. The petals are somewhat similar to the peach blossom, but with a heart-shaped outer edge. You can cut either from the top or from below but be sure to cut round and smooth lines, and do not accidently cut entirely through the stamen or petals.

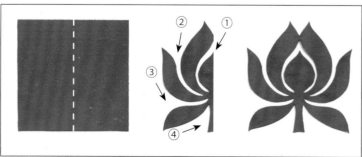

6. Lotus Flower

After folding your paper, you can start cutting either from the top or bottom.

The cut-out lines should be smooth and round. Pay special attention to the form of the petals to achieve an overall effect that reflects the vitality of the lotus flower.

7. Chinese Rose

This paper-cut uses relatively simple modeling to extract the essence of the shape of the Chinese rose. The petals are wrapped in layers. Pay attention to variety of the arc sizes and forms.

8. Chrysanthemum

This pattern is quite abstract and combines different views of the flower in one form. The petals spread out from the center in distinct layers. When cutting, petals should be cut round and smooth with hook-shaped tips, capturing the essence of the chrysanthemum.

9. Magnolia

After you have mastered cutting the basic S-shaped line, it will be easier to create the magnolia cut-out. Magnolia has a simple form with round and smooth line changes. Pay special attention to making the interior lines clear.

10. Morning Glory

This paper-cut starts with the cutting of the flower's center from which the other elements grow. Curves should be added to the petals in order to heighten the aesthetic quality.

11. Peony

This is a complicated shape that starts from the top, and then the petals are cut from top to bottom at one go. The petal curvature should show dynamic changes. The form of the leaves should be concise, and care should be given to their relationship to one another, as well as their positioning relative to the petals.

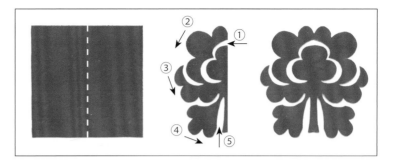

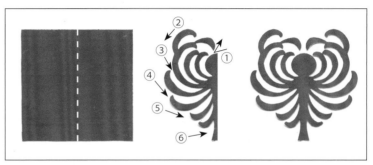

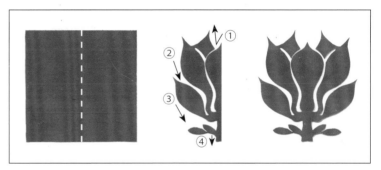

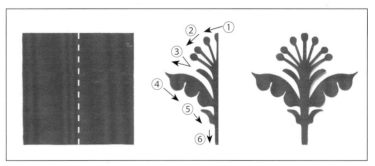

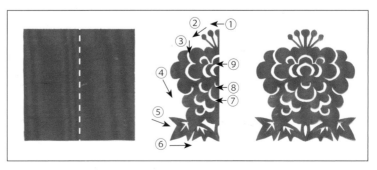

Freeform Patterns

Patterns using flowers and plants are varied and have highly decorative effects, making them suitable to use for embroidery on clothes, shoes and other everyday objects. Traditional folk embroidery often uses paper-cuts; a paper-cut is stuck to the fabric to be embroidered and is used as a pattern much like a stencil. Thanks to this practical application, embroidery patterns make up a large part of folk paper cutting.

In this section, we mainly introduce "shoe head flower" paper-cuts. These paper-cuts are used as patterns in embroidering shoe uppers, where traditionally flowers and plants are the most common subjects. When creating a shoe head flower paper-cut, instead of using the usual square, the paper should first be cut to match the shape of the shoe surface. These are freeform rather than symmetrical paper-cuts and as such do not use folded paper.

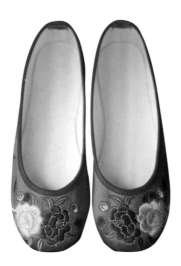

Embroidered shoes

1. Chrysanthemum

Chrysanthemums come in numerous varieties, but in general, they are simpler in form than many other flowers. It is important to determine a suitable starting position, generally starting from one end, and working from stem to leaves, petals and then finishing with leaves and stem

again. Beginners should start with a pattern that is generally circular but not too round. Petals should converge toward the center; as they are thin and numerous, be careful not to cut them off.

A single chrysanthemum is often used in patterns; below are three different variations.

Thin petal cut-outs should be graceful but firm.

This chrysanthemum flower is basically circular. In the course of cutting, the petals should be cut finely but remain sturdy, converging toward the center.

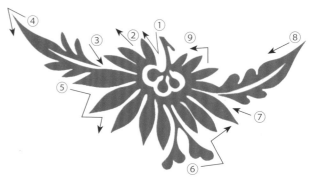

The lines of the leaves, stems and blossom should all be smooth.

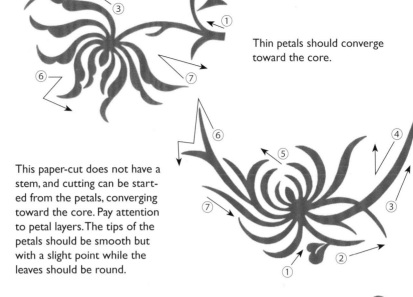

2. Wild Chrysanthemum

Having a similar shape to the chrysanthemum, wild chrysanthemums grow on hillsides, in grasslands and fields, and by roadsides, coming in a variety of forms. In paper cutting, we often represent them in profile, generally starting from the stem and working around. Note that each petal should change in size and width, and the distance between petals is also irregular.

Thin petals should converge toward the core.

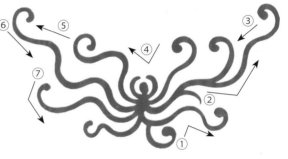

This paper-cut does not have a stem, and cutting can be started from the petals, converging toward the core. Pay attention to petal layers. The tips of the petals should be smooth but with a slight point while the leaves should be round.

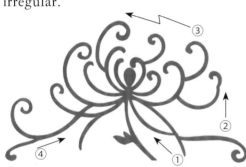

The delicate petal tips arc in different directions to reflect changes of forms, sizes and layers.

This paper-cut focuses on exaggerated petals without stems or leaves. Cutting starts from the right to the left. Pay attention to the curve changes of the different petals and the freely flowing lines.

3. Lotus Flower

The lotus is a perennial aquatic flower. Before emerging out of water, its leaves are rolled into telescopic shapes closely clinging to the stalks. Its buds are peach-shaped and the flower form comes in many varieties. Lotus flowers are a favorite subject for many kinds of artists due to their large size and gorgeous color. They also embody desirable qualities: enduring blazing sun and emerging unstained from the mud and muck.

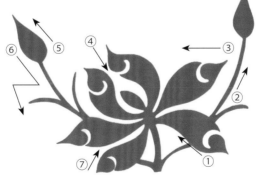

The petal tips should be cut with sharp angles, the buds should be smooth, and the grass thin and firm with vitality.

This work is a bit more complicated than the above one. Therefore, the arrangement of the flower, buds, stems and grass must be closely considered, with particular attention paid to the overall density so that the paper-cut is full of vigor and vitality.

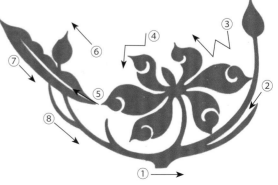

4. Bamboo

Bamboo is composed of three parts, the stalk (or trunk), branches and leaves. Bamboo stalks are connected by joints, which are represented by cuts that extend nearly all the way across without being cutting off.

Bamboo branches stem from the right and left of the stalks. Old branches have short joints and are dense; they should be represented vigorously. Tender young branches have long joints and are sparse; they should be cut round and smooth.

Leaves can either face upward or downward. Upward-facing leaves look like the upside-down Chinese character 人 and downward-facing leaves resemble the Chinese character 介.

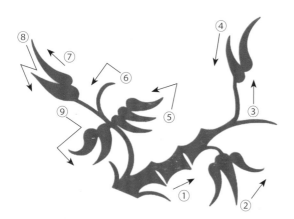

5. Chinese Rose

The Chinese rose, also known as the "Queen of Flowers," is large and fragrant. Chinese rose petals are divided into simple and multiple petals, and the flowers often grow in clusters.

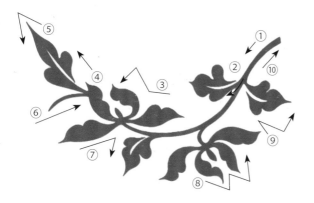

Creating Chinese roses usually begins with the branches. The tips of the petals must be pointed, and the lines should flow.

This cut-out is in side view, demonstrating the shape of the Chinese rose. The two roses, one upper and one lower, respond to each other. They should be of differing sizes and there should be variety in their leaf and petals shapes.

6. Orchid

Growing in mountains and valleys, the orchid has leaves that are strong and slender, sleek and bright. The flowers are graceful and elegant with a strong and pure fragrance. It is a favorite flower among artists.

Orchid leaves are generally in a group of three downward strokes, with one long and two short. Several patterns can be produced based on these strokes. Cutting usually starts from the root. The leaves should be slender and the tips of the petals should demonstrate curvature.

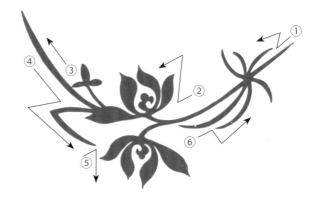

7. Plum Blossom

Blooming in the cold of winter, the plum blossom is able to resist frost. Therefore it is highly prized, and along with the orchid, chrysanthemum and bamboo, is one of the "Four Noble Ones" or "Four Gentlemen," famous plants depicted by generations of Chinese artists.

Plum blossom branches should be strong and sturdy, capable of demonstrating that they can withstand frost and snow. The flowers are shown in differing positions and at various

stages of blooming. They should be arranged in groups showing an appropriate density.

You should start cutting from the trunk and make your way around before finally returning to the trunk. The blossoms should be round and full, the trunk thick, and the branches slim and sturdy.

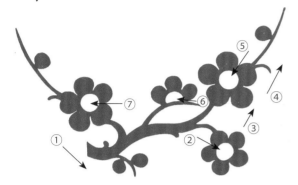

8. Grape

With its vines, leaves and clusters of fruits in summer, the grape has rich decorative elements, making it very suitable as a subject for painting and paper cutting.

Start cutting from the branches on the right. The lines should be cut round and smooth, and the fruits should connect with one another, showing variety in direction and size.

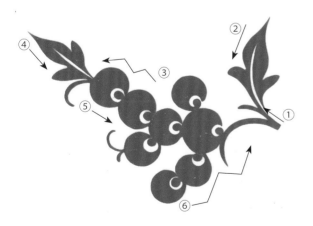

9. Peony

The peony is honored as the "King of Flowers," traditionally symbolizing prosperity, happiness and peace. The flower is large and its leaves are luxuriant. The flower can have a simple or complex petal arrangement, although in general paper-cuts are marked by simple petals.

Although abstract, the peony paper-cut is relatively complicated. Start from the flower center and then cut outwards alternating from left to right. When dealing with petals and leaves, they should be varied in size and in the directions they face. The branches should cross one another and extend in different directions as well.

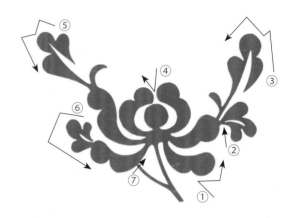

10. Camellia

Thanks to its beautiful posture, dark green and lustrous leaves, and gorgeous shape, the camellia is valued by the horticultural world. It is associated with loveliness, modesty and prudence.

Camellia petals are bowl-shaped. A simple camellia has five petals, and the flower looks like an enlarged plum blossom. When cutting, the flower edge should be rounded, the petal size even, and bracts varied in size, with slim, straight buds and clearly-defined leaf veins.

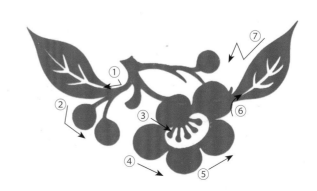

11. Rose

Large and gorgeous, the rose symbolizes beauty and love. The stems have many thorns, the leaflets are oval or elliptical, and the edge has blunt sawteeth. The flower shapes are varied and beautiful.

The relative positions of the flower, leaves and small bracts should be determined before cutting begins. The rose paper-cut should be plump with clear gaps between petals, and the petal shapes should show variety.

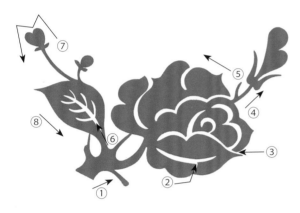

12. Cherry

Cherry tree leaves have an elongated egg-shape with a sharp front end. The fruit is nearly spherical and red. In cutting this pattern, attention should be paid to the position of the fruits and leaves. The cherries should be rounded and full, and the stems and leaves should show texture. The leaves should show variety in size, length and curvature, with slim and straight veins.

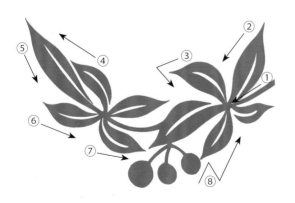

13. Persimmon

The persimmon fruit is oblate in shape, and depending on the variety, the colors can range from light orange to dark reddish orange.
In this paper-cut the fruits are symmetrical, presenting a feeling of fullness and robustness. In contrast, the leaves demonstrate agile charm with veins going off in different directions.

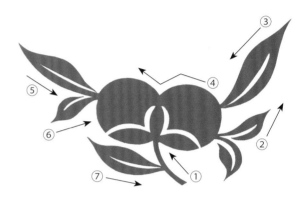

14. Pomegranate

This work shows a lateral view of pomegranate, but the decorative effect is enhanced by adding a symmetrical flower in the middle of the fruit, giving richness to the form.

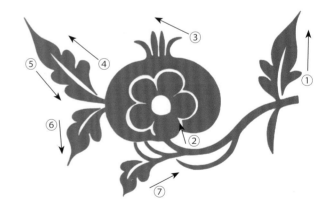

15. Pea

The pea plant is an annual vine with elongated oval leaflets and white or light purple flowers. It has a long oval pod and the peas inside are round.

Consider the layout of the whole picture in advance taking into consideration appropriate

density. This paper-cut emphasizes the profile of the pods. The shell cut-outs should be full and thick, and the peas inside should be of different sizes, all with smooth edges although not too spherical. The stems should be sturdy and the leaves should convey a sense of swinging.

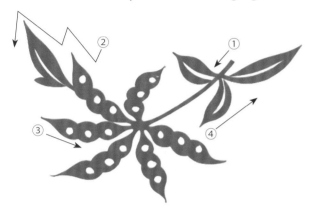

16. Nandina

Nandina's Chinese name is a homonym for "blessing from Heaven," implying the elimination of all evil things, which makes it a popular flower during the Spring Festival.

It is slightly red when young, becoming violet red in autumn. In the period from August to October, it grows spherical scarlet berries. The stems are straight with a few branches, radiating out at each level in opposite pairs.

The aesthetic appreciation of nandina mainly focuses on its leaves. Its leaves are cut similarly to those of bamboo. Attention should be paid to the changes in size and position when cutting the berries. The sizes and angles of the stem nodes should be distinct.

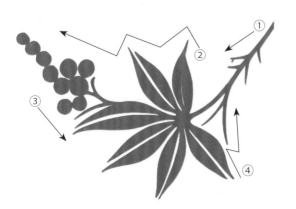

17. Lily

The lily looks elegant and pure, traditionally connoting "conjugal bliss" and "everything desirable." Chinese people regard it as an auspicious flower in wedding ceremonies. The lily has an elegant shape, green and graceful leaves, and slim stems.

In this paper-cut of two lilies, one is big and the other small, with petals facing different directions. The stems should be smooth and straight, and the leaves should have elegant movement.

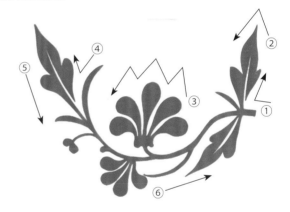

18. Watermelon

Sweet and juicy, watermelon is refreshing and enjoyed during summer. This paper-cut shows a side view of the watermelon. The line pattern on the outer rind of the watermelon should be clear and convergent. The leaves have a palm shape, and are cut along the direction of the leaf veins. The vine lines should be light and agile, avoiding rigidity.

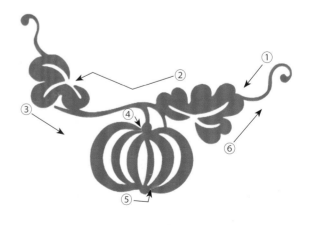

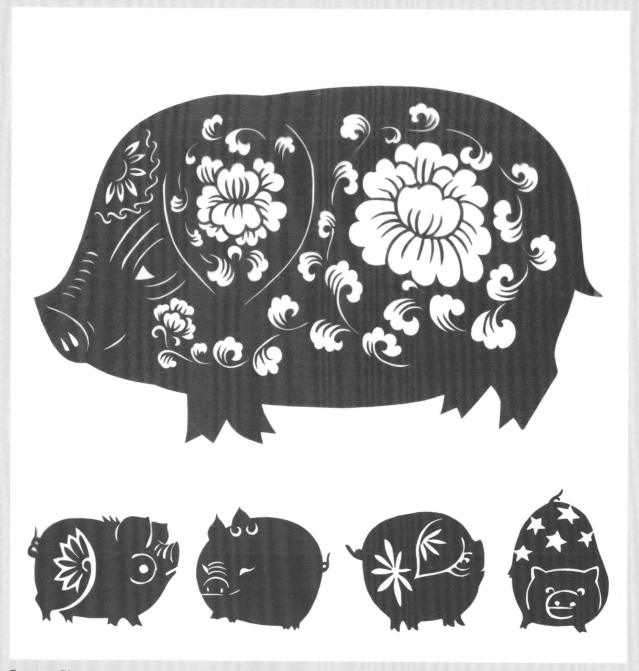

Fortune Pigs

In Chinese culture, the pig is one of the signs of the zodiac, and it symbolizes fortune. In this paper-cut, the patterns on the big pig's body are of peonies, which indicate wealth and honor and the leaves seem to be floating around the blossoms creating a wonderful decorative effect.

Chapter Four Animal Paper Cutting

A nimals are a very important subject in paper cutting. In addition to domestic animals, mythical creatures such as the dragon and phoenix are popular as are the twelve animals of the Chinese zodiac.

Cutting paper animals is more difficult than flowers and grass. To produce high-quality animal paper-cuts, careful observation and demanding training are necessary. However anyone can try his or her hand at animal shapes following the templates in this chapter.

As your own work becomes more advanced, it is important to gain an understanding of the individual animal before cutting. One needs to become familiar not only with the anatomy of animals but also their movements and behavior. The most successful paper-cuts resemble their models not only in shape but also in essence. This is only possible through getting to know animals in daily life, grasping their characteristics, and then using appropriate form manipulation and exaggeration to strengthen the effect.

Symmetrical Patterns

Animal patterns using bilateral symmetry are marked by simple modeling, appropriate exaggeration and interesting changes of forms. This method is suitable for cutting single animals. Generally, a piece of square paper is used and folded in the middle before cutting.

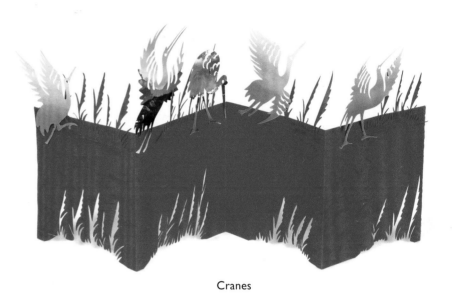

Cranes

1. Goldfish

When creating a goldfish using this example, we are using an exaggerated overlooking angle. First cut the head, and then in turn the eyes, body, tail and finally the external outline. The eyes should be cut smoothly, and the patterns on the tail should present a sense of elegance and swing.

Extra care should be taken when cutting the patterns on the body, and the external outline should be produced cleanly and neatly.

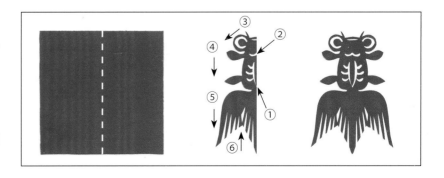

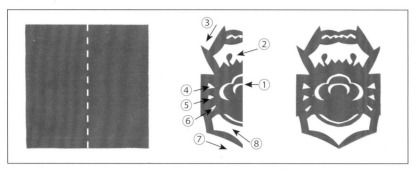

2. Crab

This work takes a relatively abstract shape emphasizing the shell. Compared with the other eight claws, the front claw should be much bigger and should look robust and forceful. The patterns on the shell should be produced at one go.

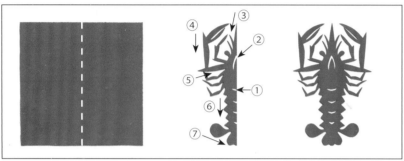

3. Lobster

First cut the patterns on the back representing the shell, making sure your scissor track is smooth. Then cut the lobster head and body. When creating the claws and antennae, the lines should be stiff and sturdy but full of a sense of elasticity. The body cut-out should be flexible.

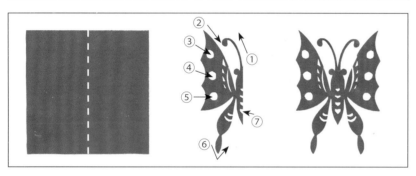

4. Butterfly

The shape of the butterfly is delicate, and the paper-cut should demonstrate its sense of flying elegance. Creating two main wings and tail wings are the key to this paper-cut. The round holes on its two wings should be basically of the same size.

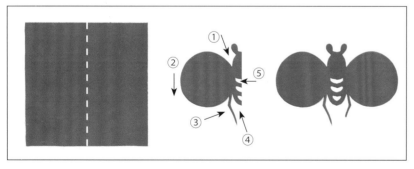

5. Bee

Though the lines of the bee are simple, its character can be expressed by means of the pair of big wings. When cutting the bee, pay attention that the wings are symmetrical and round. The scissor track should be smooth and clean.

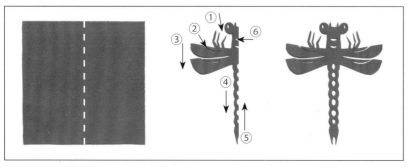

6. Dragonfly

The dragonfly's body looks like a string of connected beads, and the two pairs of wings should convey a sense of lightness. While cutting, the round holes of the dragonfly's body should be basically the same size and the eyes a bit protruding.

7. Frog

First the scale of the frog's body should be considered with special importance given to the eyes. The scissor track must be fluent and smooth. The form of the frog's hind legs should be highlighted but without too much exaggeration. The toes should capture the potential for a forceful spring and remain gentle but firm.

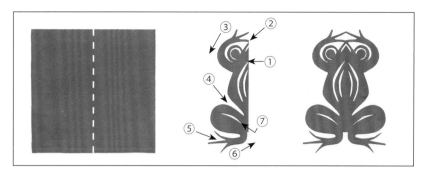

8. Tortoise

Arcs and circles on the back should be cut delicately in order to create a feeling that the tortoise is climbing. The scissor track should be smooth and clean.

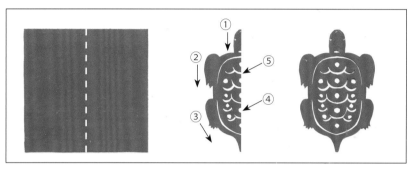

9. Swallow

An agile and graceful swallow flying freely in the spring sky is created by applying smooth and symmetrical lines. Some additional patterns can be cut to represent the swallow's feathers so that it won't turn out monotonous. The tails should be pointed, just like the blade of the scissors.

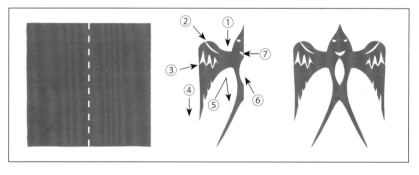

10. Owl

The owl has very big and bright eyes. There are various patterns such as triangles, circles and wavy lines on its body, which convey the sense of layers of feathers. At the same time, the owl's feet should appear more rugged.

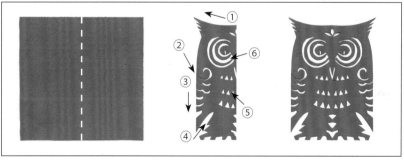

11. Pig

This piggy's eyes are round and cute, while its pair of nostrils should be connected naturally with decorative charm. The ears are another distinctive characteristic. Adding more patterns like ovals and curvy lines should make it more vivid and interesting.

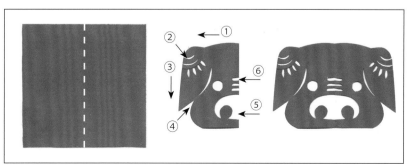

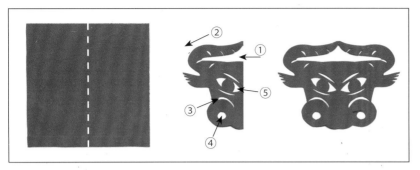

12. Cattle

When creating cattle, the form of the nostrils should be exaggerated, the horns forceful and the eyes full of vigor. The eyes are olive-shaped and the pupils inside them should be round and big in order to express the vigor of the animal.

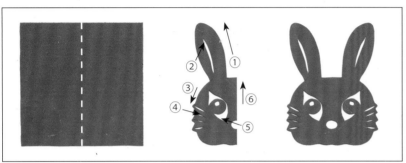

13. Rabbit

Pay attention to the stylized layout of eyes, ears, whiskers and mouth. The ears should be long and plump while the whiskers are slender. For the eyes, the small round holes are cut out to reflect the rabbit's tenderness. Take care with the composition of the ears and face.

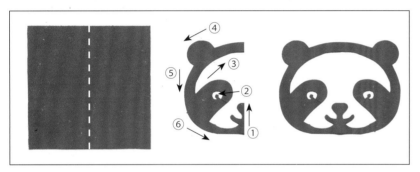

14. Panda

The panda is one of the most beloved and precious animals in the world. The paper-cut should convey the panda's charmingly naïve appearance. The ears, face and eyes of the panda should be round. When cutting the round face, the scissor track should be smooth.

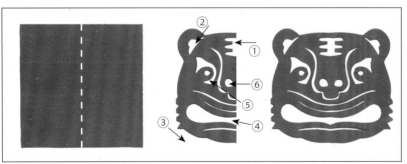

15. Tiger

In this paper-cut, the head must capture complex characteristics, looking strong but good-natured, fierce but lovely. Special attention should be paid to the Chinese character 王 (*wang*, king) on the tiger. Lines should be smooth and simple.

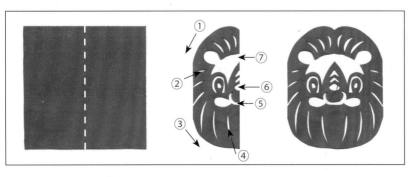

16. Lion

The male lion makes for quite a majestic image. In the course of cutting, special attention should be paid to the smoothness of lines and natural curvature of lion mane. The spaces between the lines of the mane should be wide in order to express the lion's ruggedness.

Freeform Patterns

Animal paper-cuts should be vivid and capture the animal's movement, vitality and appeal. The forms can be either realistic or imaginative but if animal paper-cuts look too much like real animals, they will lose their aesthetic appeal. The forms can capture many moods, appearing elegant, interesting, funny or lovely, and can serve to symbolize people's wishes and expectations for a better life.

Now we turn from the symmetrical cuts in the previous section to freeform cutting, which provides greater flexibility for expression as well as complexity.

1. Butterfly

Although taking different forms, the butterflies in both of these paper-cut works are appealing and elegant. In the first work, one must pay attention to the number and position of the large and small wings. The patterns should change according to the wing shapes. The body should be full, and the antennae and legs should be slim and sturdy.

The second paper-cut is characterized by a stronger decorative effect due to the more complicated wing patterns and charming lower winglet. The bending gesture of the antennae should correspond to the dynamic movement of the winglets.

2. Bird

Birds have a great variety of shapes and postures. Patterns can range from abstract to detailed.

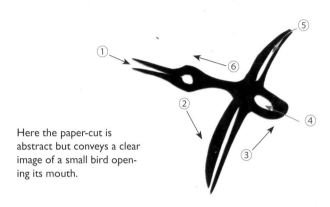

Here the paper-cut is abstract but conveys a clear image of a small bird opening its mouth.

The form of a flying bird relies on the wings conveying a sense of movement in the air.

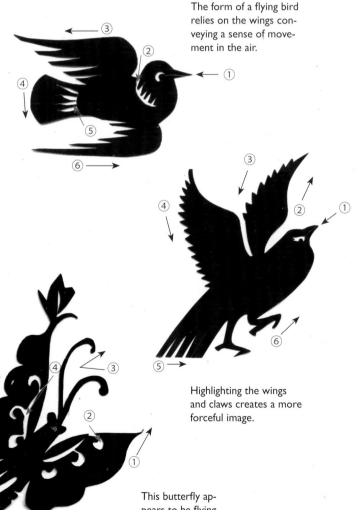

Highlighting the wings and claws creates a more forceful image.

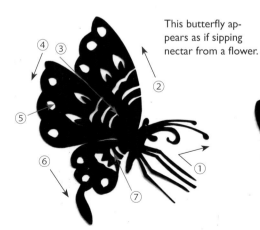

This butterfly appears as if sipping nectar from a flower.

This butterfly appears to be flying toward flowers.

3. Carp

This is a relatively complicated paper-cut, so careful attention should be paid in the course of cutting the eyes, scales and tail.

4. Wild Goose

While the image is quite abstract, a dynamic sense of flying with the wind should be highlighted. In the course of creating the small circle representing the eye, you should turn the paper while cutting, which involves careful hand-eye coordination.

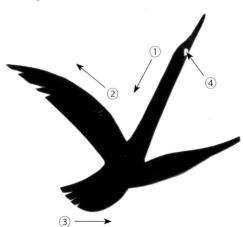

5. Hen

This paper-cut uses a relatively realistic treatment to portray the hen's act of eating rice. Capturing the form of the neck is the key to the success of this work, and the curvature should be smooth.

6. Water Bird

Most water birds live in wetlands or coastal areas. Their distinguishing characteristic is the long beak that helps them to catch fish.

Many water birds swallow fish, and so a bird with a whole fish in its stomach makes for a striking image.

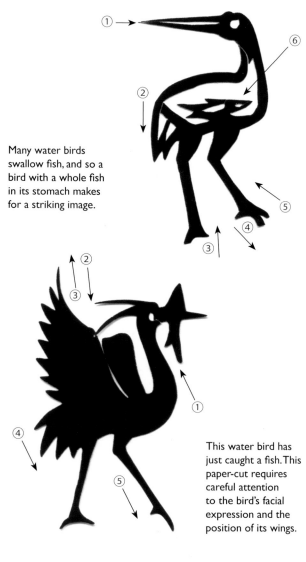

This water bird has just caught a fish. This paper-cut requires careful attention to the bird's facial expression and the position of its wings.

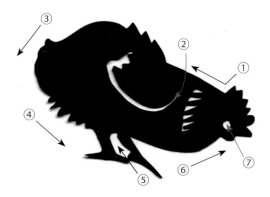

7. Rooster

This paper-cut presents the profile of a crowing rooster. The mouth should be neat and smoothly cut, and the feathers and tails should convey a decorative sense.

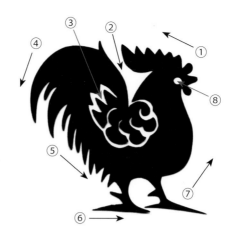

8. Pheasant

The pheasant's head looks downward as if it is running hastily. This gesture of the head is the key to this image.

10. Rabbit

This paper-cut presents an adorable domestic rabbit in profile. The ears should be highlighted and exaggerated, and care should be taken so that its tail is a suitable length.

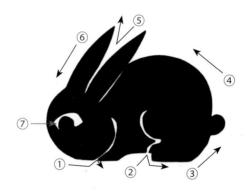

9. Ostrich

The legs of the ostrich are slim, long and straight, portraying quite a leisurely sense.

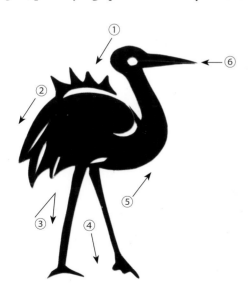

11. Black Bear

It is important to capture the correct proportion of the head and body of this little bear, as well as the facial expression and action of the upper limbs. The lines should be round and smooth.

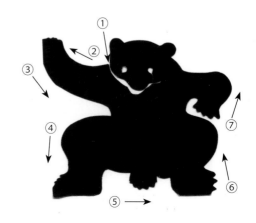

12. Pig

Before cutting, imagine this scene: A fat pig is running with its two big ears swinging. This dynamic sense should be highlighted. As pig has a fat body that covers a big area, adding patterns to it will allow you to avoid leaving blank spaces and increase the artistic quality of the entire work.

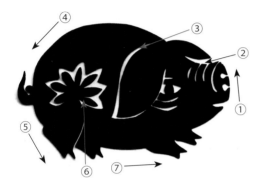

13. Wild Boar

In this paper-cut, the boar is running. Therefore, the four limbs should present this dynamic sense of movement.

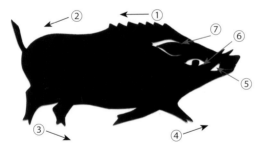

14. Camel

The camel is commonly known as the "Ship of the Desert." It has a solid presence conveyed by its overall shape and especially its humps.

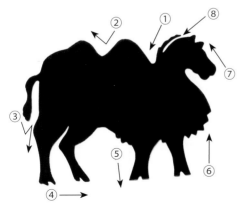

15. Bull

The bull's posture is greatly exaggerated to capture its power and force.

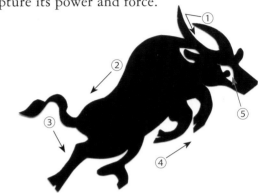

16. Horse

In China, the horse is acclaimed for its courage in marching ahead. At the same time, it is traditionally seen as a messenger of good luck. This spirit is captured in the horse's posture, and attention should be paid to the long and elegant tail and mane.

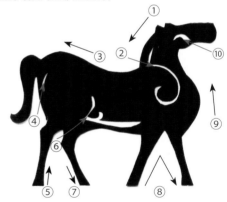

In this paper-cut, the horse is standing still but it is important to capture the attention and erectness of the head posture.

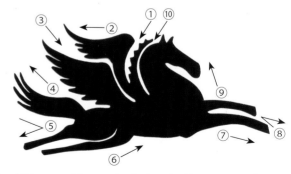

In addition to adding a pair of wings, in this paper-cut, the horse's four limbs should be outstretched in a leap.

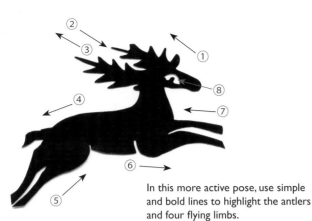

In this more active pose, use simple and bold lines to highlight the antlers and four flying limbs.

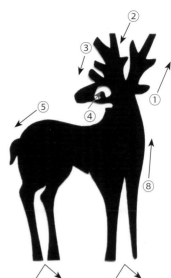

In this variation, the little deer looks backward, note the subtle position of the neck, head and antlers.

17. Deer

Most deer live in the forest eating plants and leaves, and their gentle, quiet quality should inform the image. In general, male deer have a pair of antlers while females have none.

In this paper-cut of a small deer standing still, attention should be paid to the antlers.

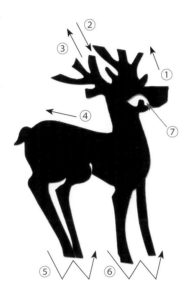

In the resting posture, attention should be paid to the positioning of the limbs on the ground so that a leisurely and carefree manner is presented.

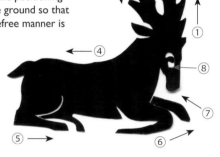

18. Goat/Sheep

In many ancient Chinese bronze inscriptions, the Chinese characters 吉祥 (*ji xiang*, auspicious or lucky) were substituted for with the Chinese characters 吉羊 (*ji yang*, auspicious goat), which are similar because *xiang* and *yang* were originally the same word. The goat can therefore have connotations of good fortune.

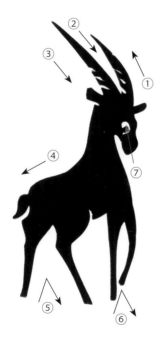

In this paper-cut of a goat, the horns are given an exaggerated treatment, and the limbs present a sense of force.

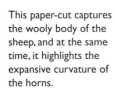

This paper-cut captures the wooly body of the sheep, and at the same time, it highlights the expansive curvature of the horns.

19. Tiger

The cutting of the curves of the neck and body is the key to producing this paper-cut. The tail should be cut in a smooth curve that captures a sense of movement. The hind legs should be produced forcefully to heighten the action. The eyes and whiskers should also be relatively exaggerated.

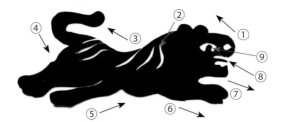

The tiger in this paper-cut is running. Pay attention to the forms and directions of its four limbs, and emphasize the forward momentum of its body.

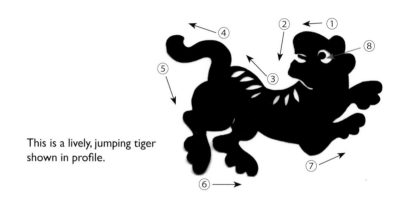

This is a lively, jumping tiger shown in profile.

20. Rat

This paper-cut of a rat in profile presents its most characteristic features—its sharp teeth and long tail.

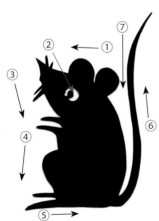

21. Cat

In this paper-cut, the cat concentrates its attention and appears to stare directly at the viewer. Its head, eyes, whiskers and tail should be exaggerated appropriately, and its body should be cut in free curves without losing accuracy.

22. Lion

The lion in this paper-cut is roaring and has a fierce demeanor. The details on its head, especially its mane, should be cut boldly with a clear decorative sense.

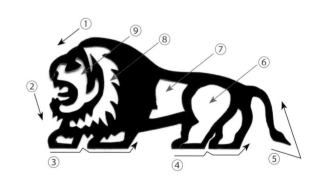

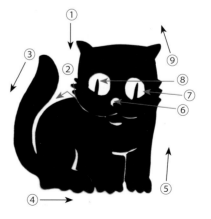

23. Elephant

This elephant is rushing forward, so you must grasp the expression of its movement. Therefore, the careful positioning of the nose, ears and eyes is vital.

24. Monkey

In this paper-cut, the monkey is very excited because it has gotten a peach. To convey the narrative, the peach can be given an exaggerated treatment, and attention should be focused on the facial expression of the monkey.

25. Phoenix

As the king of birds in ancient Chinese legend, the phoenix enjoys a status second only to the dragon. It has beautiful feathers and is often used to symbolize good fortune. According to legend, the phoenix is characterized by a "rooster head, swallow jaw, snake neck, tortoise back and fish tail, as well as gorgeous color and a height of six feet." A saying in Chinese folklore states that "all birds pay respect to the phoenix." This majestic quality should be captured in the paper-cut.

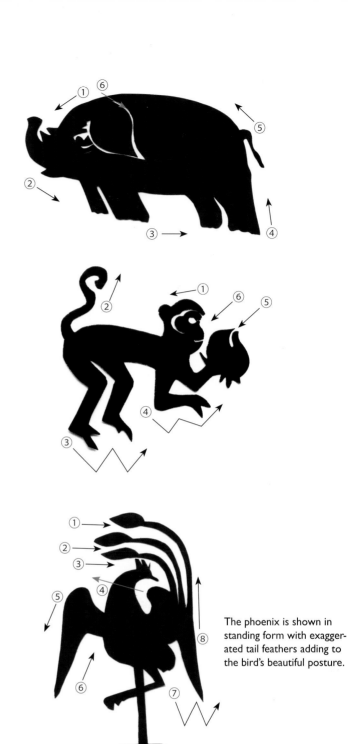

The phoenix is shown in standing form with exaggerated tail feathers adding to the bird's beautiful posture.

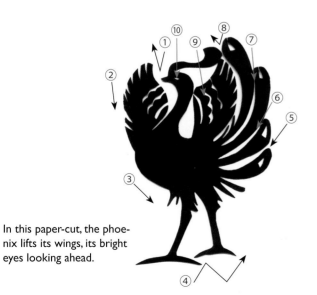

In this paper-cut, the phoenix lifts its wings, its bright eyes looking ahead.

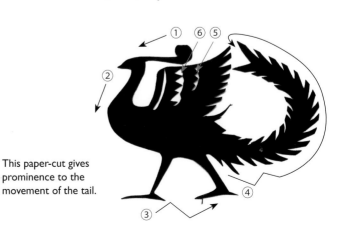

This paper-cut gives prominence to the movement of the tail.

Twelve Chinese Zodiac Animals

In ancient China, different animals representing the symbols of the zodiac were chosen based on their characteristics and periods of activity. Each zodiac animal represents a period of time known as *shi chen* or a two-hour period, with twelve animals encompassing the day. The zodiac animals take the following order: rat ranks first, followed in turn by cattle, tiger, rabbit, dragon, snake, horse, sheep, monkey, rooster, dog and pig.

Since ancient times, people and animals have enjoyed a close relationship. For thousands of years, portraits and descriptions of zodiac animals have reached very high artistic levels. For many paper-cut enthusiasts, representing these twelve animals is the most enjoyable and meaningful part of their practice.

1. Rat

A talented and adaptable animal, the rat can make holes, climb trees and mountains as well as wade in water. The rat's long tail plays a role in balancing the paper-cut. The swing of the tail should be fully expressed. The curvature of its legs should be round and smooth, and its eyes should be round with a full pupil.

2. Cattle

Cattle were vital partners in the traditional agricultural society of China, and they have always been a common subject in paper cutting. Cutting generally starts from forelimbs. Patterns can be added to the back in order to enhance the decorative quality of the paper-cut.

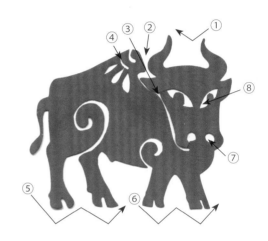

3. Tiger

Having the largest body among the felines, the tiger is characterized by strong leg muscles, hind legs that are longer than the forelegs, and large, forceful paws. The cutting should start from the paws. Special attention should be paid to the markings on the back, giving them an artistic quality. The tail should bend naturally.

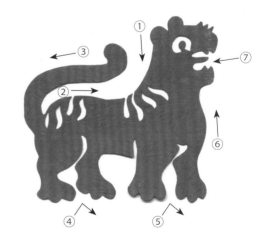

4. Rabbit

It is important to first grasp the characteristics of the rabbit before proceeding with the papercut. The body curves should express the state of the rabbit's movement.

The ears are tubular and several times as long as they are wide. The tail is short and puffy, and its hind legs are strong and much longer than forelimbs. When cutting the four legs, scissors should be used neatly and smoothly. Its eyes should have natural curvatures without being abrupt. The highlighted part should be produced at one go.

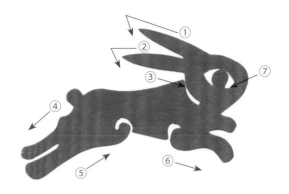

5. Dragon

The only fantastical animal among the twelve Chinese zodiac animals, the dragon stands for power, nobility and honor. With a body similar to that of a snake, it can only be properly cut when you have a full grasp of its curves. The whiskers and tail should be full of character and have varied lengths. The legs should have smooth curvatures; the eyes should be round with full and expressive pupils.

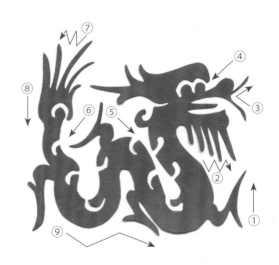

6. Snake

A reptile, the snake has a long legless body with scales covering it. It crawls due to the body's movement of flexion and extension. Therefore, the form of the snake should be presented mainly through its body curves.

Capturing the "spirit" of the snake can be only achieved through understanding the bendable nature of the snake body and the tongue sticking out from its mouth. Some patterns can be added to the body to heighten the decorative effect of this paper-cut.

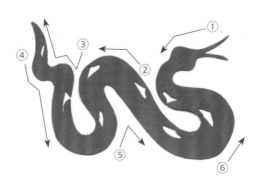

7. Horse

The horse has always played an important role in farming, transportation, hunting, exploration, recreation, sports and other human activities. In this paper-cut, the mane and tail should be decorated using a combination of the imaginary and the real. The four running limbs demonstrate a sense of force and power, and the patterns on the body express the structure of the legs.

but strong limbs, wide and straight back, plump muscles, and round, thick and compact body. The whiskers under the chin, another main feature, are slim and graceful representing the tender nature of the goat. The horns should have a different curvature than that of the body.

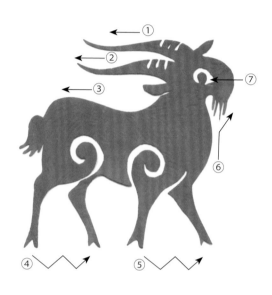

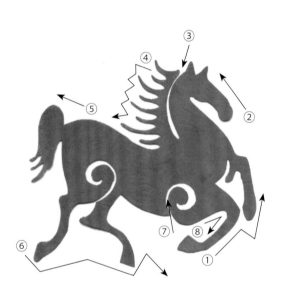

8. Goat

Characterized by elegance, gentleness and sentimentality, goat have had a close relationship with humans since ancient times, and have long been the subject of adoration and worship. The Chinese character 美 (*mei*, beauty) in an ancient form of writing called oracle bone script was based on the form of the character 羊 (*yang*, goat) with a large horn on the head. Early on, the goat (which is interchangeable in Chinese with "sheep") was already a symbol of beauty and goodness. Goat are often used to symbolize wishes for luck and a good life.

The main features of the goat are the short

9. Monkey

A fellow primate, the monkey's actions are in many ways similar to those of human beings, and it has very high intelligence. Its limbs

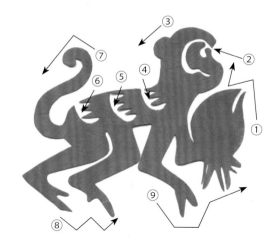

are nimble and agile. In traditional Chinese culture, people express good wishes through the combination of a monkey and a peach. As the peach can represent "longevity," the combination of monkey and peach can present wishes for fortune and long life.

When cutting, be sure that the peach is slightly exaggerated and highlighted, while also paying attention to the relation between the position of the monkey and the peach.

paid to its raised head and curved tail. Patterns can be added to the body to enhance the decorative effect.

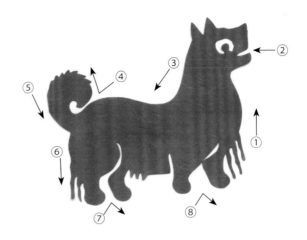

10. Rooster

The rooster is the bird most commonly raised by human beings. In ancient China, the rooster was seen to possess five virtues: a bright mind, a fighting spirit, courage, benevolence and reliability. This gave the rooster a very high status, and therefore, the rooster has always been a common subject for paper-cuts. Its tail feathers and small feathers are beautiful, and this should be captured through the decorative patterning.

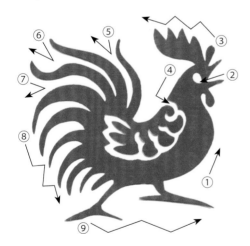

11. Dog

The dog is well-loved by humans, and it is the subject of many people's favorable expressions. In the course of cutting, attention should be

12. Pig

While the pig is often regarded as being dirty and lazy, in fact, the pig is an intelligent animal and it stands for affluence and leisure in traditional Chinese culture. Being used not only as food but also for making leather and medicine, the pig is acclaimed as having "treasures of the whole body" and is an important subject in paper cutting. The ears are the most distinctive part and can be appropriately exaggerated. Its tail should be small and delicate, and adding texture to the nose brings about a more vivid piece of work.

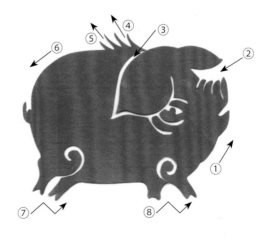

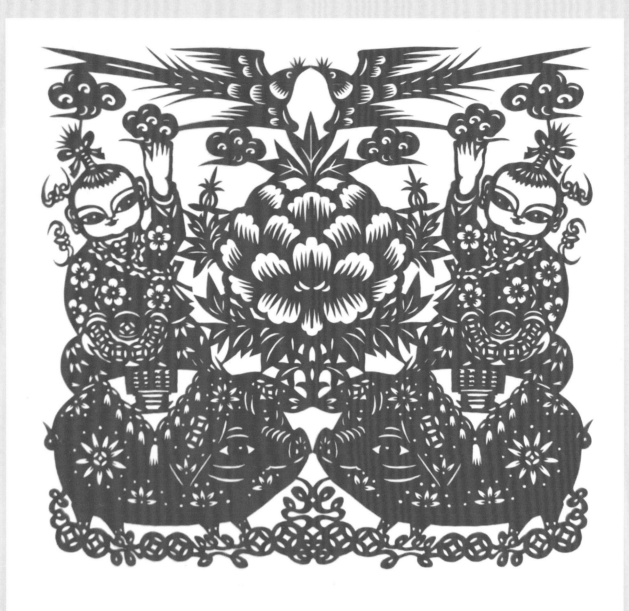

Countless Happiness

This work is complex in both design and meaning, and it is composed from top to bottom. Starting at the top, the pair of flying magpies indicates happiness, with the six auspicious clouds under them symbolizing that things will develop as one wishes. Below the clouds is a pair of children holding ancient coins symbolizing fortune; they surround a peony in full bloom. The lovely plump pigs are covered with carpets indicating a good harvest. At the bottom is a string of *ruyi* ancient coins signifying everlasting happiness.

Chapter Five Paper Cutting of Chinese Characters and Symbols

In Chinese paper cutting, there are many "conventional" Chinese characters and symbols, and their connotations are well-known and widely recognized. With their long history, Chinese characters are extensively used in paper cutting. As many Chinese characters are pictographic, they actually resemble the things to which they refer. Exaggeration or simplification of different components can make the paper-cuts more vivid or decorative.

Symbols

In traditional Chinese paper-cuts, you may sometimes see the character 卐, either alone or as part of pattern. Although in Western culture this symbol is now associated with the Nazis, it originated in ancient India and also appeared in Persia, Greece and Rome. In paper-cuts, it appears as a symbol of good fortune, success and long-lasting happiness.

The importance of a paper-cut is primarily judged by the significance conveyed by its symbols rather than by its technique. Maybe you have noticed that the same symbol is often used repeatedly. It is not because paper cutting artists lack creativity but rather because these symbols are an ingrained part of the culture, symbolizing good wishes and meeting the needs of folklore rituals and festivals.

1. *Fangsheng* (Double-Diamond) Pattern

A traditional Chinese geometric decorative pattern, the *fangsheng* (方胜, double-diamond) pattern, which is formed by two identical intersected diamonds, is often used in architecture. People in ancient times used the character 胜 (*sheng*, conquer) to drive evil away and secure safety and happiness, and the *fangsheng* pattern was an important auspicious decorative pattern in ancient China.

The double-diamond mostly appears in the form of a geometric pattern; it may appear independently or be combined with other patterns. In the course of cutting this pattern, be sure that the two diamonds are of equal size and that their intersection forms a third perfectly diamond.

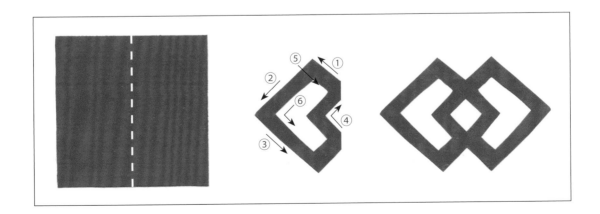

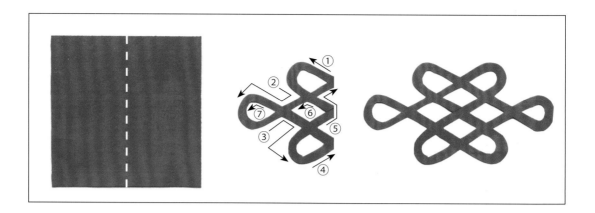

2. *Panchang* (Endless) Pattern

As one of the "eight treasures" of Buddhism, the *panchang* pattern simulates the traditional craft of thread knotting. Without head or tail, beginning or end, it represents long-lasting and eternal good luck and happiness. Therefore, it is called *panchang* (endless). It is widely used in auspicious decorations, being applied to architectural features, as well as other adornments, including buttons and ornaments.

When cutting, use the bilateral symmetrical paper cutting method. *Panchang* lines should be produced with consistent width and space, and it is important to keep a smooth line when making the turning.

3. Double-Coin Pattern

Coins have not only monetary value but also symbolic connotations, representing luck and auspicious treasures in China. They are seen to get rid of devils and repel evil spirits. The double-coin pattern was so named after its shape of two connected ancient copper coins, which stands for "good things coming in pairs." In ancient times, homophonic connotations meant that this pattern also signified "double completeness."

Cut this pattern following the order from ① to ⑦.

Chinese Characters

Paper-cuts of Chinese characters are often used in traditional festive activities: for example, paper-cuts of the character pattern 囍 (double happiness) are used in wedding ceremonies; paper-cuts of 福 (*fu*, good luck) are posted during the Spring Festival; and paper-cuts based on a version of the character for 寿 (*shou*, longevity) are used for birthday celebrations.

1. 福 (Good Luck)

During lunar New Year, Chinese people often post paper-cuts of the character 福 in different

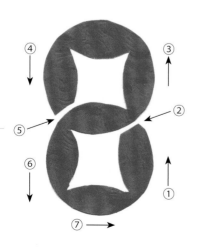

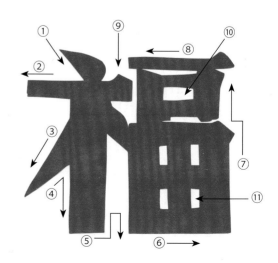

sizes on their gates, walls, windows and lintels. This is a time-honored custom. The character 福 means good luck and fortune, expressing people's good wishes for a better future. This paper-cut is sometimes posted upside down, since this invokes a homophone for "arrive" and therefore represents wishes for the arrival of luck, happiness and prosperity.

When cutting, the position of each part should be arranged properly. Otherwise, it will bring about a sense of top-heaviness.

2. 囍 (Double Happiness)

A wedding is one of life's most important festive rituals. Every family celebrating a marriage ceremony posts paper-cuts of a stylized version of the Chinese character 喜 (*xi*, happiness) on their external doors and interior windows.

The origin of 囍 (double happiness), according to the most popular legend, dates back to Wang Anshi (1021 – 1086), a famous writer in the Song Dynasty. According to the folk story, when Wang Anshi achieved the double success of

passing the imperial examination and becoming an ideal son-in-law of a rich man, he wrote two big Chinese characters 喜 side by side, which were posted on the gate of his house.

These pictures are full of joy, as they represent a meaning of double happiness, a symbol that has grown to be pervasive in Chinese culture.

In the course of cutting this symbol, be careful that the upper should be tight, and the lower should be loose. The snip should be clear and lines should be straight.

3. 壽 (Longevity)

Giving birthday congratulations is a traditional Chinese custom, and a paper-cut of the character 壽 is absolutely necessary because it stands for health and longevity. The character 壽, as it appears in paper-cuts, is evolved from a more ancient form of writing, small-seal script. In the course of cutting, remember that the pattern should be symmetrical, and lines and curves should be clear and natural.

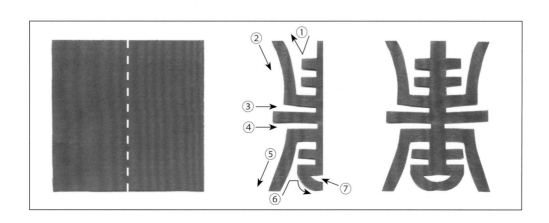

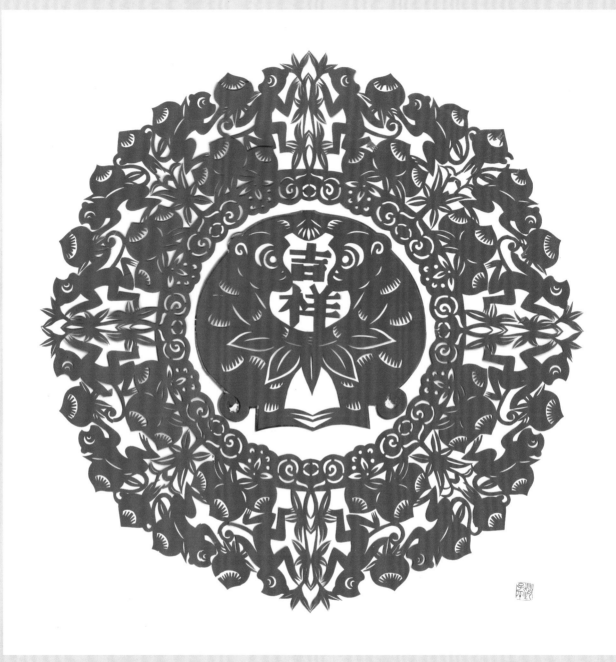

Pair of Auspicious Monkeys

In this paper-cut work, the focus is on the middle of the work where two monkeys embrace Chinese characters meaning "auspicious." The shape outlining these characters takes the form of a gourd, another symbol of good fortune. The monkeys are encircled by *ruyi* shaped auspicious clouds, giving the meaning that things will go as one wishes. Around the edge are eight pairs of monkeys together with peaches and peach branches, signifying longevity. This paper-cut is usually used to decorate the home during the Year of the Monkey.

Chapter Six Paper Cutting of Combined Patterns

After grasping the basic practices of cutting lines, flowers, animals, characters and symbols, designs can be composed combining these various elements. These paper-cuts use stylized, simple and bright images, creating balanced patterns that carry deep significance in traditional Chinese culture.

Flowers and Birds

When cutting a pattern that uses flowers and birds in combination, you can refer to the techniques learned previously for cutting each of the individual elements.

In paper cutting in combination of birds supplemented by flowers, consideration should be focused on the bird form, which consists of such main parts as the body, head, wings, tail, legs and claws. The main portion of the body usually takes an oval form with few changes; more variety appears in the head and other body parts.

Flowers and plants often have symbolic connotations in folk culture, with elements from real life taking on significance and imbuing the pattern with auspiciousness. For example, plum blossoms are often combined with magpies representing "being radiant with joy." Lotus flowers, fat babies, goldfish and carp in combination stand for abundant harvest and future generations.

1. Magpie and Plum Blossom

The traditional combination of magpie and plum blossom like the top right paper-cut is beloved by the public, and also among the most popular subjects for paper-cut artists. Cutting starts from

the plum blossoms at the bottom and then continues upward. The circles representing the flower buds should be cut from the outside.

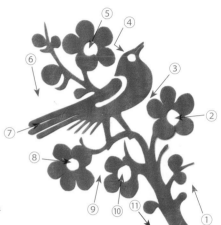

2. Peony and Little Bird

The middle paper-cut on the right focuses on the little bird. Cutting starts from the peony trunk at the bottom, and then continues upward. When creating the leaves be sure that the veins are symmetrical. The patterns on the body should transition gradually from small to large.

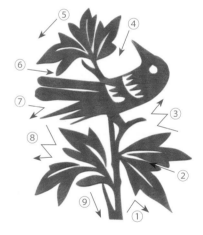

3. Wild Chrysanthemum and Little Bird

In the below right paper-cut, the two wild chrysanthemums should have varied shapes and be arranged around the little bird. Refer to the cutting technique previously explained for each of these elements. Be careful that the flowers and leaves are arranged in different densities.

4. Stylized Flower and Little Bird

The flower in the top left paper-cut takes a different form, and the bud should be highlighted. In the course of cutting, pay attention that the flower centers show variety while still adhering to the principles of slim and straight lines and smooth curvatures. The petals should also vary in size and the leaves should strengthen the sense of irregularity.

5. Stylized Bud and Bird

Below left is a traditional paper-cut wherein the bird occupies most of the space. It should be produced elegantly, especially the feathers on its body, which should be treated delicately. Although the ends of the flight wings are very slim, they should be sturdy and forceful. The tail feathers give texture and stature.

6. Stylized Flower and Bird

The top right paper-cut still gives prominence to the bird although it is quite small. The treatment of the neck can influence the overall feeling, so it is an important element. The texture of the feathers is also vital. In this composition, emphasis should be given to the relationship between the bird and the flowers, the relationship of the flowers with one another, and that of the flowers to the stems.

7. Bamboo and Little Bird

The below right paper-cut sets the little bird against the background of bamboo. The cutting technique for the little bird is much simpler than that of the bamboo. Cutting starts from the earth at the bottom, then continues upward to create the old bamboo trunk, stems, joints and leaves. The final effect of the trunk should be vigorous and forceful, and the new bamboo on the top should be round and smooth.

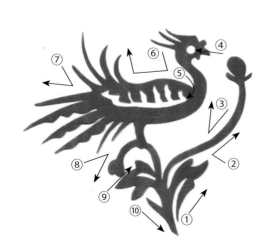

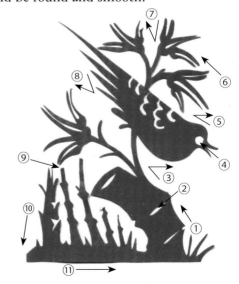

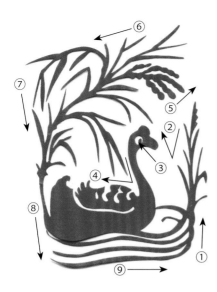

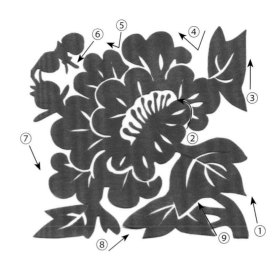

8. Goose and Water Grass

In the top left paper-cut, the neck of the big goose, the ripples in the water, and the water grass should be harmonious. The curve of the neck is the key; the momentum of the goose can only be captured through this curve. The ripples should be neat and precise, with smooth curvature and equal distance between waves. The direction of the water grass should correspond with the movement of the goose.

9. Little Duck and Water Grass

You can refer to "Goose and Water Grass" for the basic technique of the below left paper-cut. The most important element is the curves of the ducks, which call attention to their movement. The waves in this paper-cut are different in form from those in "Goose and Water Grass," however they should also be kept neat and the

curvature should be smooth. Again, the direction of the grass should correspond to the movement of the ducks.

10. Peony, Pomegranate and Bee

The peony in the top right paper-cut is relatively realistic. In the course of cutting, pay attention to the changes of the petals and the overall aesthetic quality of the form, carefully considering the size, layout and density of leaves.

11. Chrysanthemum and Rooster

In the below right paper-cut, the chrysanthemum's modeling is rather abstract, and attention should be paid to the number and gesture of the petals. The rooster's exuberant manner should be expressed by the curves of its neck and body. The tail should not only be round and elegant, but also present a sense of irregularity.

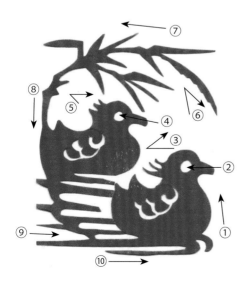

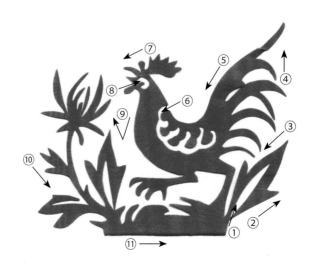

Chinese Characters and Other Patterns

The combination of the characters 寿 and 喜, in their stylized form, with different flower and animal patterns is the most common type of paper cutting art. The different pairings can evoke multiple meanings in traditional Chinese culture.

1. Symmetrical 寿 and Plum Blossom

This paper-cut gives prominence to the character 寿 decorated with bats and plum blossoms. The form of this character is based on its original seal script form with some changes. Refer to the cutting method previously learned when this pattern is being cut. The pattern incorporates straight lines with full curves in a pleasing composition.

2. Symmetrical 寿 and Phoenix

This character appears as a horizontally-extended version in small-seal script. The whole composition develops horizontally, using the flying phoenix wings and tails for emphasis.

3. Double Happiness, Lotus Flower and Mandarin Duck

The combination of characters with flowers signifies a sweet and happy life for newly-married couples. In this paper-cut, the proportions of the character and the duck pattern are basically the same. Cutting of the character should have straight lines horizontally and vertically, and demonstrate symmetry. The lines of the lotus flowers and mandarin ducks should be produced smoothly with clear notches.

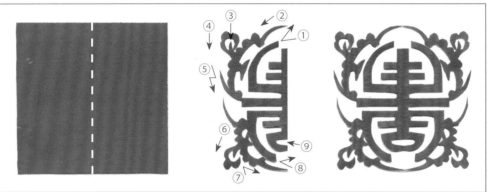

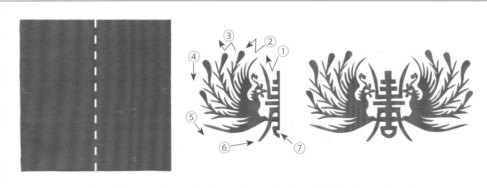

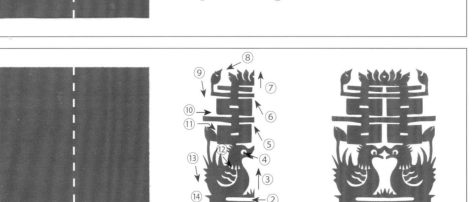

4. Double Happiness, Peony and Phoenix

A popular subject, this paper-cut is often used on festive occasions. During weddings this kind of paper-cut is often posted on furniture in the house and on doors and windows, representing wishes for a happy new life. Cutting can start either from the character or the phoenix. The double happiness character should have straight lines horizontally and vertically, and the lines of the peonies and phoenixes should be smooth.

5. Double Happiness, Plum Blossom and Magpie

The combination of double happiness, plum blossom and magpie is also a beloved and lucky subject. Cutting can start either from the Chinese character or from the plum blossom. When creating the plum blossom and magpie, exaggeration should be used to emphasize characteristic forms and heighten the artistic quality. The double happiness character cannot be too large; it should be smaller than the pattern below it in order to achieve a balanced layout.

6. Double Happiness and Dragon

Paper-cuts with this combination of patterns are often seen in the rooms of newly-married couples, decorating walls, doors and windows, pillars, lamps and lanterns, etc. The form of the dragon, especially its head, should be exaggerated appropriately. The decorative textures of the dragon body should be clear, with lines of suitable width.

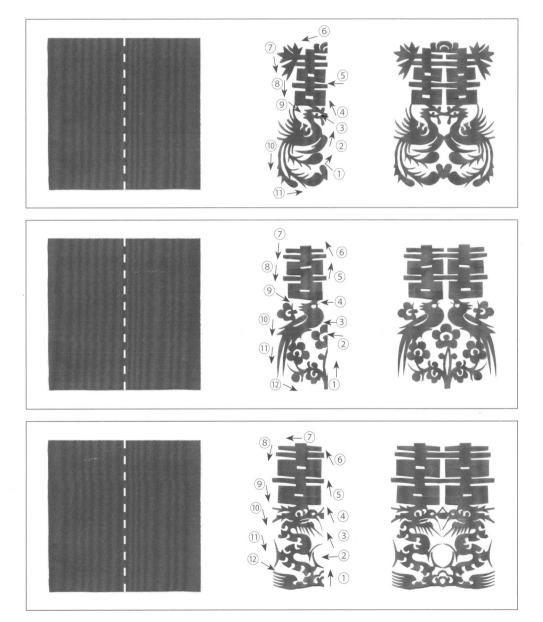

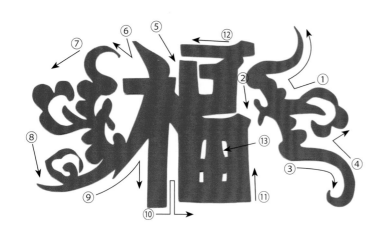

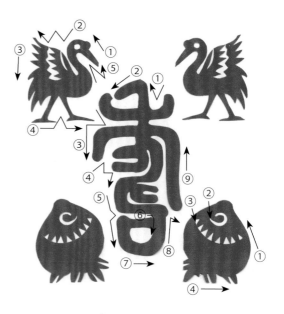

7. Character 福 and Bat

Wishes for good luck (*fu*, 福) are often expressed using the character for bat (*bianfu*, 蝙蝠) because the second character in bat is a homonym for good luck. This pattern brings wishes for luck and the arrival of happiness. The pattern is not only symbolic but also has a strong decorative effect, and can be seen everywhere in daily life.

8. Arrival of the Five Blessings

In traditional Chinese culture, the bat represents good luck and happiness. As the characters 福 and 蝠 are homonyms for "five blessings," the symbol for the "arrival of the five blessings" is composed of five bats. These "five blessings" as described in ancient Chinese texts are longevity, prosperity, health, virtue and the desire for a natural death at an old age. According to custom, the combination of these five blessings leads to a blissful life.

9. Character 寿, Cranes and Peaches

In traditional Chinese culture, the crane, which can live 50 to 60 years, is a symbol of longevity. According to legend, the peach is divine and can also bring long life. Thus the character 寿 (longevity), together with cranes and peaches, expresses people's desire for a prosperous and long life. This pattern can be seen most often at an elder's birthday party.

10. Character 福 and Fish

The Chinese word for "fish" (*yu*, 鱼) is the homophone of "surplus." Therefore in traditional Chinese culture, fish often serve as the subject of paper-cuts for Spring Festival, invoking hopes for plentitude and affluence in the new year. The combination of the character 福 (good luck) and fish thus expresses good wishes for the coming year and is a common pattern used to enhance the festive atmosphere.

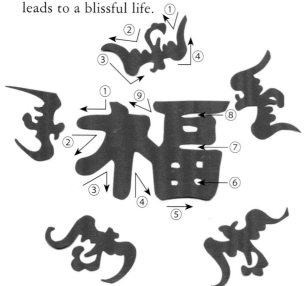

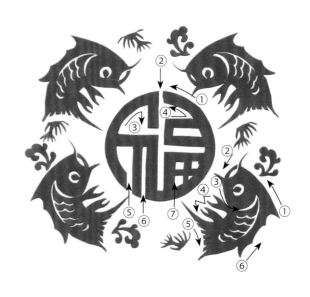

Symbols and Other Patterns

While symbols can have deep significance on their own, they have rich meanings when used in patterns, and their combination with flowers and animals can have profound connotations. When cutting the following patterns, the bilateral symmetrical paper cutting method is used.

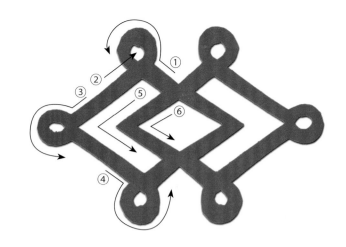

1. *Lu Lu Tong*

A symbol for success, this pattern combines double-diamond patterns and circles. Without a starting or ending point, but with paths that lead everywhere, it represents everything going well.

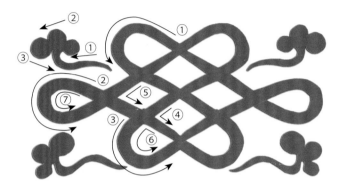

2. *Ruyi* and *Panchang*

This represents the combination of endless knot (*panchang*) and auspicious cloud (*ruyi*), which carries the meaning that a person is capable of dealing with all people or clever in dealing with people.

3. *Fu Zai Yan Qian* (Double-Coins and Bat)

This is a common pattern; the combination of the bats and copper coins is a homophonic symbol for "blessings abound."

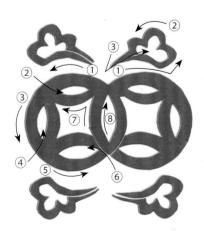

4. Double-Coins and *Ruyi*

This pattern is also commonly seen in China. The combination of double-coins and auspicious cloud is a homophonic symbol for "having plentiful financial resources."

Flying *Apsaras* of Dunhuang

The flying *apsaras* (celestial maidens) of Dunhuang are emblematic of the remarkable art of the Dunhuang Grottoes, the famous Buddhist cave art site in northwest China. These images appear in nearly all of the hundreds of caves there. The flying *apsaras* show characteristics of varied origins including India, Central Asia and different regions of China. Having no wings, feathers or halos, they fly in the sky by means of fluttering dresses and colorful ribbons, a stroke of creative genius by the Chinese artists who created them.

This paper-cut work was made after the author visited Dunhuang. He used a white paper to cut out the flowing dress and soft arms of the *apsara*, and the yin yang method means that from this sheet, two beautiful *asparas* were created. The harp resting in the *asparas'* hands gives the feeling that you can hear these beautiful sounds from afar.

Chapter Seven Yin and Yang Paper Cutting

A new form of paper cutting was created in 1978, the yin and yang paper cutting. It won the first prize for creative design in Shanghai.

The yin and yang paper cutting method relies on the traditional characteristics of patterns, solid basic skills and a rich imagination. The work is divided into two parts, yin and yang, and each of these two parts can also stand as a separate piece of work. Every yin and yang paper-cut work is original and unique.

Right-handed cutters generally should cut in a counterclockwise direction. It is vital to coordinate the movement of the two hands in order to keep the work within ideal visual range and to maintain better control.

In addition to traditional single-color paper, the cutter can also try using multi-colored paper. Multi-colored paper-cuts are a new form of work, produced by using color periodicals as the paper, and delicately arranging the pattern to take advantage of the colors. Color paper cutting art can be vibrant, modern and full of artistic tension.

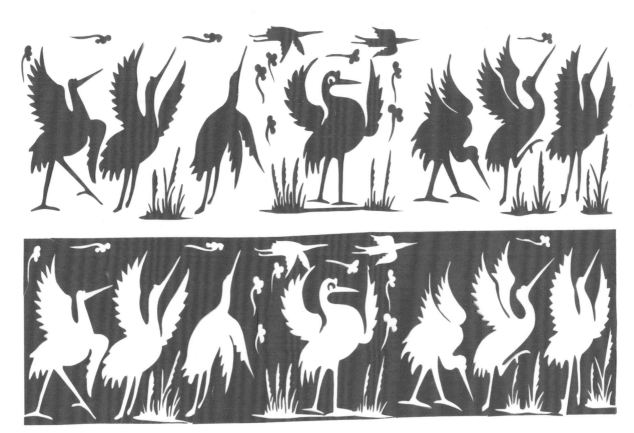

A Group of Cranes

The morning, when the sun is slowly rising, is the time when the red-crowned cranes enjoy the most happiness. They are in various stages of flight, dancing and circling.

Plum Blossom, Orchid, Bamboo and Chrysanthemum

In traditional Chinese culture, the plum blossom, orchid, bamboo and chrysanthemum are collectively referred to as the "Four Gentlemen," and have long been beloved subjects for artists. They convey the characteristics of self-reliance, uprightness, modesty and pureness.

Imperial Expedition

This paper-cut expresses the grand scene of the armies of Emperor Qin Shihuang (259 – 210 BC).

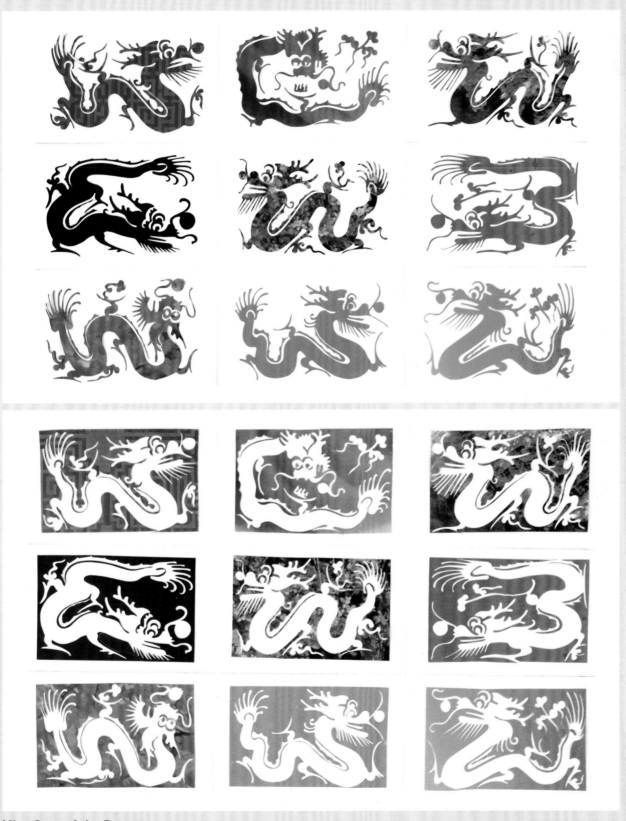

Nine Sons of the Dragon

In Chinese legend, the dragon has nine sons, each with his own unique appearance. It is interesting to note that "nine sons" doesn't mean that the dragon has exactly nine sons; "nine" instead stands for a large quantity and the highest rank in traditional culture.

The Monkey King

This paper-cut work depicts a scene from the *Journey to the West*, one of the Four Great Classical Novels of Chinese literature, written in the 16th century. In this pilgrimage tale, Tang Sanzang and his three disciples, Sun Wukong (the Monkey King), Zhu Bajie and Sha Wujing, finally received the Buddhist scriptures after going through 81 tribulations on their western voyage.

Chapter Eight Appreciation of Works

Every art has its own unique style. For example, Chinese painting focuses on brush painting techniques, Western oil painting emphasizes the fluid use of color, and woodcut prints pay particular attention to the graphic qualities of black and white. Similarly, for a work of paper-cut to be deemed excellent, it must be superior in its own style and characteristics. Then how can we best appreciate a paper-cut work? Appraising a work in relation to the following qualities can help:

- Auspicious significance: Patterns with special symbolic meaning are the most important subject of Chinese paper cutting. These not only express wishes but are also reflective of important cultural heritage.
- Proper exaggeration: Paper-cut works do not set as their goal a realistic representation. They should exaggerate beautiful and important characteristics while simplifying less desirable ones. This makes for a more pleasant and aesthetic composition.
- Lovely forms: While exaggeration is important, an overall balance with well-formed components makes for a charming and desirable work.
- Beautiful lines: An excellent paper-cut should reflect the most refined expression of the language of paper cutting: it should have straight lines and smooth curves. Whatever its subject, it should be produced vividly and with vitality.

In this chapter, my paper-cut works are presented.

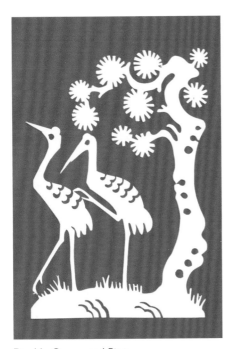

Double Cranes and Pine

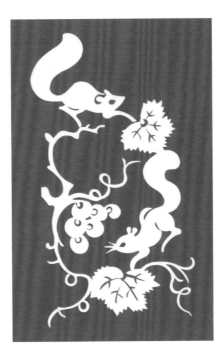

Squirrels and Grapes

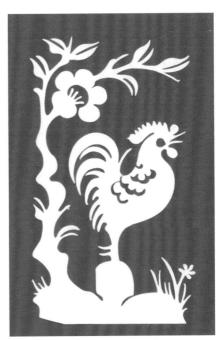

Rooster and Peach Blossom

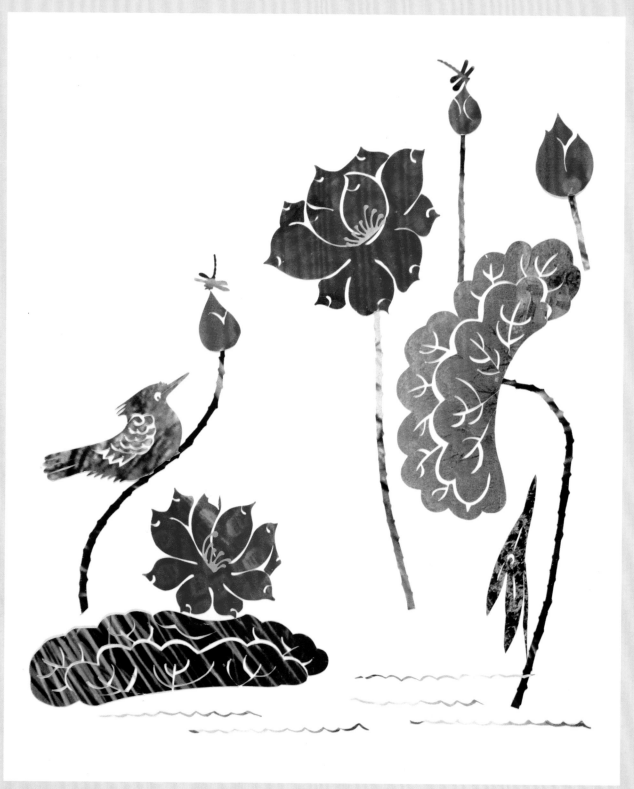

Pond in Summer

In the summer, the lotus flowers are in full blossom. The kingfishers and dragonflies buzz fly around the lotuses creating a beautiful summer scene.

The paper used in this work comes from magazines. With a rough design in mind, the author chose those pages whose colors and patterns were best suited to the different elements of the composition.

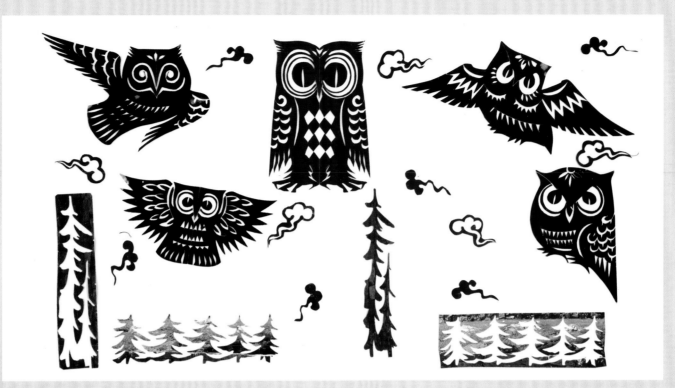

Wise Birds

A traditional belief holds that the owl, a symbol of wisdom, can dispel evil.

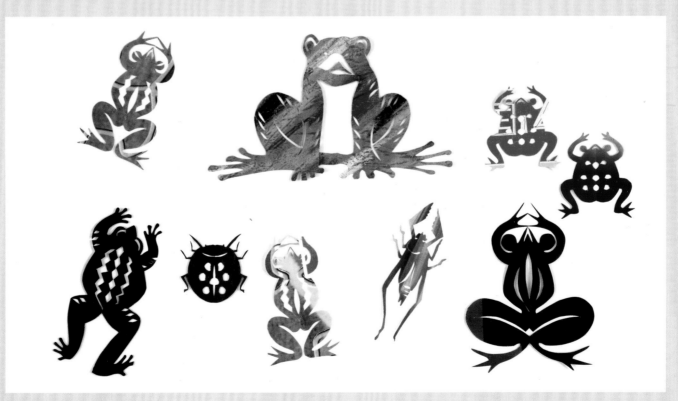

Frogs

The frog is an auspicious animal according to Chinese custom, and it indicates that one can obtain endless wealth or reach almost any other goal.

Sports

This paper-cut captures the graceful postures of figures taking part in different sports.

The World under the Sea

This paper-cut is a gentle reminder that everyone's efforts are needed in order to protect the gorgeous world under the sea.